EXPOSURES

WOMEN & THEIR ART

EXPOSURES

WOMEN & THEIR ART

TEXT BY BETTY ANN BROWN & ARLENE RAVEN

PHOTOGRAPHS BY KENNA LOVE

FOREWORD BY ALESSANDRA COMINI

NEWSAGE PRESS

DEDICATION

This book is dedicated to all the women represented in these pages, who gave so generously of their art and lives . . . and to all their colleagues who continue to work and make a difference.

ACKNOWLEDGEMENTS

A special thank you to the following people for their help in making this book a reality; Donna Tennant in Houston, Carol Becker in Chicago, Ruth Weisberg, Jeri Waxenberg, Hannah Theile and Jytte Lokvig in Los Angeles. Research was funded in part by a grant from the California State University, Northridge, Foundation.

We particularly thank our publisher, Maureen R. Michelson, for her compelling insights, knowledgeable direction and unfailing patience.
—*Betty Ann Brown, Arlene Raven & Kenna Love*

EXPOSURES, WOMEN & THEIR ART

Address inquiries to
NewSage Press, P.O. Box 41029, Pasadena, California 91114

First Edition 1989

Printed in Korea through Overseas Printing Corporation

Library of Congress Catalog Card Number 89-061205

ISBN 0-939165-10-4 (Clothbound)

ISBN 0-939165-11-2 (Softcover)

ISBN 0-939165-13-9 (Limited Edition of 100 Books)

Contents

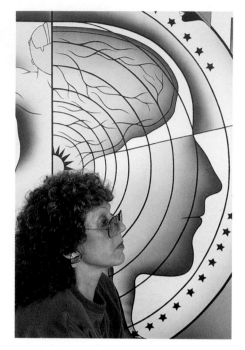

Judy Chicago

This book is a genuine American sampler, offering an authentic cross-section of present-day American women and their art. In word and image it gives exposure to 50 artists who vary in outlook, background, age, geographical locale and choice of expression, but who are linked by a common primary activity—the making of art.

Some of the art is representational; some of it abstract. Some is of short duration—performance art—while other examples are intended as permanent icons for contemplation, whether two- or three-dimensional. The physical means chosen to convey artistic ends differ widely, from conventional pastel and oils to neoned kinetics, complementing the rich assortment of artistic credos encompassed in this sampler. For this is a modern sampler and the art, presented in the context of America Today, reflects the aspirations, obsessions, worries and whims of the artist as citizen in a remarkable land that fosters both art as medium and art as message.

"I want to be effective in these times," said the pacifist artist Kathe Kollwitz in a post-World War I Germany that somnambulistically followed Hitler's rise to power. Some of the artists in this sampler relentlessly employ their art to provoke public awareness of the ever-present dangers of militarism and greed in a nuclear age. Other artists use their talents for self-expression to confront the conservative vision of a return to traditional roles for women ("Church, kitchen, children," as Hitler had summed it up), confirming or expanding, rejecting or transforming these same roles in intriguing, memorable imagery. Still others continue the sensuous American love affair with materials that prompted abstract expressionism in the 1940s and promotes compelling variation and novel juxtapositions at the end of the century.

Is a book on "Women and Their Art" different from a book on "Men and Their Art"? Yes and no. In this sampler there are artists who happen to be women and who inadvertently or purposefully make that their subject matter by exploring the dimensions of their individual existence. Since "woman" has never stood for the generic in the history of humanity, as has "man," woman-as-subject can seem to take on private or hermetic autobiographical aspects that might not be read as such were the depictor of woman in her physical, social, and psychic guises a male artist. (What would critics have said, for instance, if Diego Rivera had painted Frida Kahlo's motifs and Frida Kahlo had painted those of Diego Rivera?) Does a gender-anchored view diminish the universality of the experience rendered? Not if one remembers that there are artists who happen to be men.

But no man or woman "happens" to be an artist. Just as no one "happens" to speak five languages or be in favor of democracy. One is born to it—to being an artist—by predisposition and talent; one achieves mastery of it by dint of study, hard work, thought, experimentation, doubt, observation, striving, perseverance and above all, by following an inner imperative—sometimes buoyantly joyous, sometimes fatiguingly compulsive, always mysterious. "Brahms, not bombs," we used to hear. "Babies, not bombs," women have replied, actions speaking louder than words. Women, in fact, are more accustomed than men to the act of creation. To live in America in the 20th century means, for an increasing number of women, to have a chance at *multiple* creativity, artistic as well as biological.

It is the new conscripts in the army of artists that make a book on "Women and Their Art" so informative, so representative and so different ultimately from a book on male artists at this juncture in the march of events. There always have been a few women artists, in every century—even if time temporarily ignored them—but now in the new melting pot of a late 20th century America which is no longer the land of plenty for all but is still the land of opportunity for many, there are more practicing, professional women artists than ever before in the history of the world.

Exposures, Women & Their Art is not only an appetite-whetting sampler but a celebration of creativity. A national celebration with an emphasis on artists *with* their art works, captured in words by Betty Ann Brown and Arlene Raven, and on camera by Kenna Love, who with infinite variety and invention multiplies our aesthetic experience and gives us in essence a double exposure to women and their art.

Alessandra Comini
Professor of Art History
Southern Methodist University

"There always have been a few women artists, in every century—even if time temporarily ignored them—but now, there are more practicing professional women artists than ever before in the history of the world."

—*Alessandra Comini*

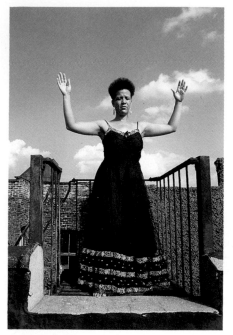

Kaylynn Sullivan

Theologian Mary Daly has said that "to exist humanly is to name the self, the world and God." *Exposures, Women & Their Art* is about women who work to create such names in the visual arts. It is about painters like Ruth Weisberg, who use painting to reconstruct their autobiographies. This book is about performance artists like Rachel Rosenthal who combine theatrical presentation with visual arts setting and poetic dialogue, in order to come to terms with such global issues as our relationship to the environment and to the animals that populate that environment. It is about sculptors like Ruth Ann Anderson who erect mammoth images of the Goddess, in search of the sacred significance in their lives, and in ours.

The artists in this book are daughters, mothers, wives, lovers, friends who—like most of their American sisters—work. They work to better understand and more effectively communicate what life in general, and perhaps their lives in particular, mean in this era.

We explore the places in which these artists work. Some work in corners carved out of their homes. Joyce Treiman's studio is her garage, where she paints among storage and refuse. Betye Saar makes her ritual objects in the converted kitchen of her home in the Topanga Canyon hills of Los Angeles. Others work in loft or studio spaces transformed from their original industrial intent into expansive arenas for visual exploration. Kathryn Jacobi works on the fifth floor of a Los Angeles office building, just a few blocks from Skid Row. Deborah Remington and Ida Applebroog work in well-lit, white-walled lofts in New York City. In Houston, Joanne Brigham works in one of the many wooden shacks that line the fence between her home and the adjacent cemetery. In Corrales, New Mexico, Jaune Quick-To-See Smith works in an adobe garage that opens onto her horse's corral.

We discuss where the artists present their work. Although many exhibit and sell through commercial galleries, others have less traditional venues. Jerri Allyn presents her performances in restaurants; Cheri Gaulke likes to perform in churches. Jere Van Syoc takes her grisly anti-nuclear sculptures-on-wheels to the Venice Beach boardwalk in Los Angeles. One of Linda Vallejo's dozen exhibitions scheduled for 1989 is in the art supply store around the corner from her studio.

These artists work in diverse materials and styles. Sylvia Sleigh uses traditional easel painting techniques to create a panoramic contemporary "picnic." Madden Harkness bases her intensely expressive paintings on traditional academic drawing, the kind of drawing that Renaissance artists like Michelangelo and Raphael perfected. But Harkness works on

large sheets of celluloid, a material unknown to those 16th-century Italian masters. Phyllis Bramson uses pastel and chalk, materials loved by Rococo portraitist Rosalba Carriera, but instead of beautified images of court dandies, Bramson creates fantastical dreamscapes populated by strange, enigmatic characters. Bibiana Suarez favors graphite pencils, the same used by the famed French draftsman, J.A.D. Ingres. Ingres employed graphite to execute precise, controlled drawings of his wealthy patrons; Suarez uses the same medium to create immense, dizzying portraits of her inner life.

Kaylynn Sullivan is a performance artist. Performance art, a genre pioneered by women who sought to give expression to the feminist dictate "the personal is political," combines the forum of theater, the context of the visual arts, narratives that are both poetic and informative, and the body of the artist/presenter. Many of the early feminist performances were intensely autobiographical in nature. Sullivan's ritualistic performances can include meditations on imagined colors, laying on of hands, and placement of crystals and amulets. Kim Yasuda is an installation artist, employing photographic murals, paint, found objects and natural forms to transform large spaces that viewers walk in and through.

Florence Pierce makes her abstract transcendental sculptures out of the same clear resin that is used in the plastics industry. Lili Lakich takes another material that is usually considered industrial or at least commercial—neon—and transforms it into riveting personal icons. Margaret Wharton uses manufactured objects, things as simple as chairs and books, to create whimsical characters of humor and delight.

Nancy Fried uses clay to sculpt unadorned one-breasted female figures. Ann Page's sculptures are of the earth; she combines wood, dirt, leaves, paper into elegant forms that recall the kites and origami of her Japanese heritage, at the same time participating in the formalist dialogue of modern art. Nancy Grossman's leather-covered, wooden sculpture heads and torsos can have shells or simple washers for eyes. Sharon Kopriva wraps her eerie bone and twig constructions in the same fabrics Inca artisans used to bind the mummy bundles of their honored dead. But Kopriva is not honoring those who have passed away, she is giving form to her inquiry about the unknown reality of death.

Exposures, Women & Their Art focuses on the issues with which these artists grapple. Many of the artists in this book, like Kopriva, use their technical and visual skills to give form to profound human questions. While Kopriva addresses death, her Houston colleague Dee Wolff uses her paintings and drawings to explore the Catholicism of her parents in an

"I look at the world out there—it's funny and bizarre and tragic—and I get myself worked up. Then I stomp into my studio."
—Ida Applebroog

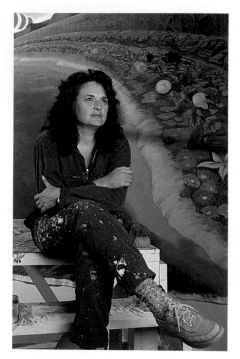

Judy Baca

attempt to find more universal significance for that religion's images of continuing life. Other artists explore spiritual issues in more cosmic terms. Younhee Paik paints compelling images of the soul (represented by a dark rectangle) soaring through infinite space. Jean Edelstein explores the history of the Goddess, how women have worshiped Her through time, how women worship and celebrate Her today.

Some artists work in explicitly political ways. Judy Baca organizes inner city youth to come together and paint expansive murals of the cultural plurality that has forged California's history. Nancy Chunn's paintings depict countries in crisis through her use of maps and chains. Cynthia Carlson works form her photographs of objects left at Washington, D.C.'s Vietnam Veteran's Memorial to create her anti-war assemblages. Connie Jenkins makes her fastidious superreal paintings as memorials to murder victims, such as the children killed in Atlanta or the victims of death squads in El Salvador. Nancy Spero has documented the torture of women and children in Chile.

Other artists use their art to examine what it means to be an individual human being today. For women in contemporary America, this can be a convoluted and complicated exploration of history, society and the self. Laurie Pincus creates large doll-like characters that act out the roles and scenarios she remembers from her childhood and time spent with her filmmaker father. June Wayne's "Dorothy Series" is a group of lithographs in which she explores what her mother's life was like—in order to understand more about her, and about her daughter and herself. Ellen Berman paints about the love and pain of her relationship with her handicapped daughter. Gretchen Lanes paints her dreams. Hollis Sigler paints the situations she sees herself and other women in, the bedroom and kitchen scenes, the dressmakers' shops, the skyscraper rooftops where her Chicago sisters pause in their urban rush.

Not all of the artists in this book use art in such explicitly autobiographical ways. But all have compelling personal histories. We discuss how they came to be artists and describe key events in their lives that led them to express themselves and their concerns in the ways they do today. Some had parents who were very encouraging of their creative efforts, such as Miriam Schapiro's artist father. Others, like Carol Neiman, recall epiphanies of artistic insight from as early as three years of age. D.J. Hall remembers her artistic experiences as being empowering, validating, as giving her access to realms totally her own in a lonely

childhood dominated by adults. Michiko Itatani enrolled in art school as a way to get experience for her writing—then ended up making the visual arts her profession. For Melissa Zink, embracing art came later in life.

For a majority of the artists in this book, the experience—either directly or indirectly—of the Women's Movement and the Women's Art Movement gave them approval to merge their personal lives with their public and artistic selves. Judy Chicago was one of the primary organizers of the Women's Art Movement beginning in the 1970s. Nancy Bowen, who grew up as an artist in Illinois during the 1970s, was encouraged by feminism to recreate female forms and explore women's sexuality. Susanna Coffey was encouraged to quit her job as a waitress and return to school to study painting. The Women's Art Movement provided a context for explorations of body and sexuality that Joan Semmel had been painting.

Exposures, Women & Their Art is not a survey of only the most visible women artists, or a "who's who" of women in the arts. Our intention has been to gather a group that would represent a sampling of women and their work in the visual arts field, a sampling that stresses diversity. Some artists are internationally known; for others, this is the first time they will be seen outside their immediate regions. The artists are Black, Latina, Asian, Caucasian. They are young, middle-aged and elderly; at the beginning of their careers or the apex. They are painters, sculptors, performance and ritual artists. Their powerful visions merge with master/mistress accomplishments of form. Their visions span what it means to be an individual in society, a political animal in a material world, a spiritual being in corporeal form. These artists offer us new answers, new alternatives, new possibilities for the difficult questions of human existence.

Betty Ann Brown & Arlene Raven

"My goal in doing my work is to tell the truth as I see it, no matter how painful or difficult that truth might be."
—*Judy Chicago*

EXPOSURES

WOMEN & THEIR ART

In two simple sentences Joyce Treiman sums up her artistic philosophy: "You ask why I paint? Why do I breathe?"

Treiman is always present in her paintings, but her presence is often elusive and mysterious. This artist is a romantic. She ranges over themes as grandiose as Greek mythology, as obscure as Baroque artists' biographies, as profound as love and death. She wrestles with Hercules' Nemean Lion, poses in Rembrandt's son's hat, huddles in an apocalyptic landscape with her arm casually draped over the shoulders of a seated skeleton. In her paintings, Treiman also meets strangers on ocean liners that float over iridescent seas, shrugs and stretches behind the grinning face of a mustachioed Joker, wears warbonnets and chiefs' blankets as she stumbles through the Wild West.

From early on, Treiman recognized her calling: "I always knew I was a painter. It never dawned on me that I would do anything else." Born and raised in Chicago, Treiman went to college at the University of Iowa where she was strongly influenced by the teaching of abstract expressionist painter Philip Guston. She received her degree in 1943 and emerged as an abstract painter. Reflecting on her 1940s abstractions, Treiman comments, "It took me 15 minutes to do them. I had to ask myself, 'Do I want to spend my life doing that?' I wanted something tough. If it isn't demanding, it isn't good."

Treiman's mature work is indeed "tough" in both thematic and formal terms. She engages the broad humanistic scope and sophisticated complexity of Old Masters. In doing so, she employs the painterly techniques of 17th and 18th century Baroque art. Then she addresses issues closer in time and space, and slides comfortably into the scintillating colorism of French Impressionism. She has created several series involving the American West. "I just like the idea of the Wild West—it's such an American icon," observes Treiman. "The Indians have become a symbol for all the people who've been picked on and ostracized."

Her musings on the significance of Native American images lead her into the topic of painting and polemics. "The issues should be out there without being propaganda," states Treiman. "I can't stand propaganda in a painting. It drives me crazy. I think you can say something in such a way that it will blow your head open without being so obvious it's banal. If the viewers can't understand something subtle, they don't deserve anything. There has to be something elusive, something metaphorical, something unexpected." She adds, "First you have to be hit on the head, really struck by it. Then you say, 'Gee, what is this really about?' You have to

be able to walk away with the image, carry it with you. That's something I call the 'after-image.' You have to be able to conjure it up later from your memory, like the Great Masters' images, such as Rembrandt's 'Nightwatch.'"

Many of Treiman's paintings have the lasting impact of which she speaks. Her "Friends and Strangers" of 1986 is a large canvas that contains two pairs of figures who totter toward a cluster of teepees in the center. On the left, Treiman, in her silk dressing gown, leans against a man in Victorian coat and hat. They gaze at the viewer with unsettling disinterest. On the right, Treiman reappears as a red-headed Native American, standing beside an equestrian vigilante. They are all embraced by the distant reaches of the golden plains, capped by a sky of satiny blue and pink. The immediacy of the image comes from the figures' adamant corporeal presence, and from their allusion to the universe of images that float through the human subconscious. They resonate with metaphor and continue to flicker behind the viewer's eyelids like the fragments of a powerful but elusive dream.

Treiman constructs her poetic figures with luscious swipes of thick, gestural paint. Her impastoed surfaces impart a sensuous rhythm to the composition. Even as the disquieting mystery of Treiman's content requires detached contemplation, the material of the image invites tactile involvement. Treiman's canvases are about as resistible as thickly frosted cakes. She loves paint as a medium, delights in sensuous impastoes and in textured protrusions of pigment. "There's a difference between painters and artists," Treiman explains. "I'm a painter . . . and an artist. There are a lot of artists who have a lot of good ideas, but painters are a special breed. We *love* paint, love what it can do, what we can do with it."

Involvement in the medium is only a part of Treiman's work. Her gratification comes when the use of paint is perfectly fused with her ideas and images. "The major challenge is to be able to articulate and perform all of it—subject and concept and media. That's really tough. And that's the difference between painting and the performing arts. For instance, in theater, the authors, producers, directors and performers are separate. But in painting, you have to come up with the idea, and be the performer and producer—they're tied up together. It's wonderful to be able to do them all."–*B.A.B.*

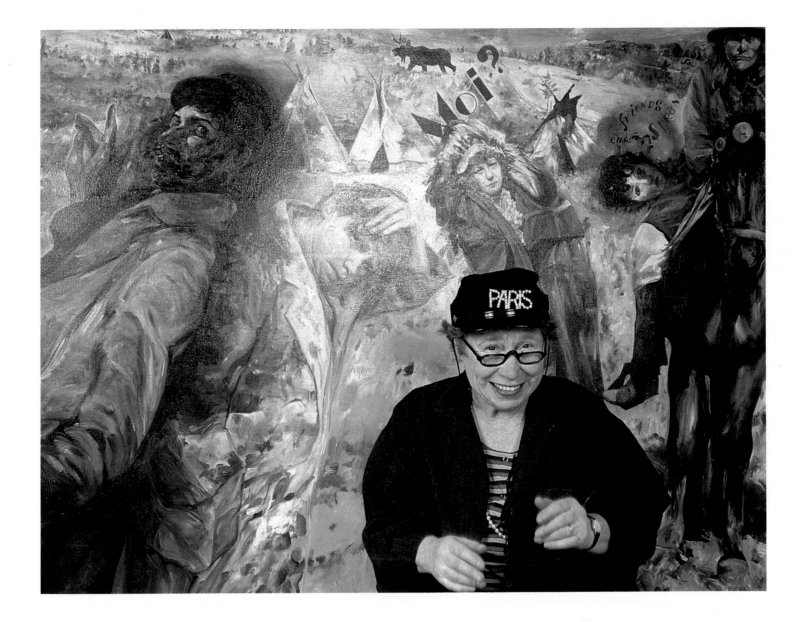

Judy Baca is a muralist. Inspired by the Mexican revolutionary muralists and their forerunners, the Italian Renaissance muralists, she creates monumental images on public walls. Like her predecessors, she employs teams of workers to execute her large and complex compositions. Unlike them, she allows her co-workers to become involved in—and receive credit for—the creation of the images they produce.

There is a social agenda to Baca's art. She combines her image-making power with her considerable organizational skills to achieve political ends, developing a successful process for employing art in social change. She has helped several diverse communities create images representing their history, their needs or their goals. The first community Baca worked with was the Chicano community of her birth, East Los Angeles. Although Baca no longer lives in East L.A., she remains strongly tied to that community. "It's my primary identity, it's familial," states Baca. "You can't turn in your brown button!" She is also aware of the importance of being a role model: "We have the responsibility to act as models, when there are so few for Chicanas to identify with."

Baca could not speak English well when she first entered public school in East L.A., but she could paint; she loved to paint. "I still like slopping that paint on, and feeling that sensual connection to it," says Baca. "It's real primal." Baca painted her way into college, receiving an art degree from California State University at Northridge. She began as a participant in several Chicano mural projects, then worked as the organizer of others. Eventually, her skills as a muralist led to a job as director of the Citywide Mural Project in the early 1970s. In 1976, Baca began working with a team of high school students from the Summer Program for Disadvantaged Youth and the Juvenile Justice Program to create the "Great Wall of Los Angeles" mural, a depiction of the histories of L.A.'s diverse populations on the cement walls lining the Tujunga Wash. In order to actually do the "The Great Wall," Baca needed to establish her own nonprofit organization. She founded the Social and Public Art Resources Center (SPARC) with painter Christina Schlesinger and filmmaker Donna Deitch in 1976. The three were interested in a political alternative to existing institutions that would acknowledge the multicultural reality of L.A. Housed in an old jail building in the seaside community of Venice, SPARC is no longer a place for "storing information and creating moral indignation" (Baca's earlier philosophy), but for producing, presenting and preserving art dedicated to social change.

Baca and the students had painted more than a half mile of "The Great Wall" when a flash flood in August 1973 swept painters, paint cans and scaffolding to the dam downstream. None of the students was seriously hurt, but all the materials were lost and the project came to a standstill due to financial problems. "But it is not ended!" Baca insists. "The Great Wall," like many of the murals in East L.A., has roots in the early 20th-century art of Mexican muralists Diego Rivera, Jose Clemente Orozco and David Alfaro Siqueiros, who appropriated the format and technique of European murals in order to portray their images of revolution and growing nationalism in Mexico. But Baca's vision is more global than that of her Mexican forefathers. "The Great Wall" is not limited to the Mexican or Mexican American history of L.A., but rather emphasizes the multicultural pluralism of the city. Also, Baca never imposed her own concepts or style on her co-workers. Instead, she developed a system in which the students did their own research and analyzed their needs. They brainstormed and allowed themselves to dream beyond any "real" limitations. Working on the "The Great Wall"—even for a short time—was a transforming experience for the group of disadvantaged youths. They developed pride in themselves and in the history of their city.

Baca's mural "World Wall" is her most ambitious project yet. A movable mural in the format of an octagonal wheel with spokes, the "World Wall" portrays the transformation of the world to peace. It represents a vision of the future without fear. Baca explains, "We transport the 'World Wall' project to a site, then work with participants to help them image the transformation of our society to peace—both spiritual and material—which ends in balance. It's a Hopi concept that we're in the situation we're in because the world has gotten too male. So this is the male and female back in balance. Many Native Americans have been talking about the teachings of the Grandmothers and there's a lot of interest in what happens when the world gets so rational and linear that we lose the ability to make intuitive leaps and imagine other ideas, dreams. We've forgotten our dreams."–B.A.B.

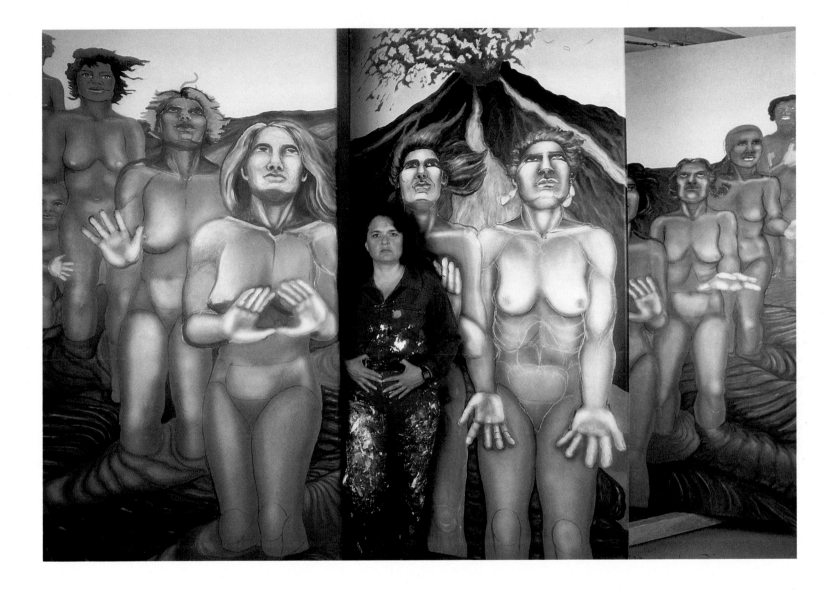

June Wayne is known both as an artist and as an arts pioneer. In 1959, she founded and then directed for 10 years the highly experimental Tamarind Lithography Workshop, which successfully revitalized the fine art of lithography in this country. Tamarind, which was funded by The Ford Foundation's Division in Humanities and the Arts derived its name from the street where her studio is located in Hollywood, California. Wayne also initiated the "Joan of Art" series of workshops in 1972 to educate young artists about the legal and economic consequences of their career choices.

As an artist, Wayne had her first solo exhibition in Chicago at the age of 17. After a year in Mexico as the guest of Mexico's Department of Public Education, she participated in the Federal Art Project of the Works Project Administration (WPA), as did many artists of her generation. She moved from Chicago to New York in the late 1930s, supporting herself as an industrial designer. With the outbreak of World War II, Wayne moved to California where she has lived and worked ever since, except for professional intervals in Europe. Throughout her career she has worked in various media including painting, prints, film, video and collage. The content of her art ranges from the personal (a visual biography of her mother entitled "The Dorothy Series") to the social ("The Justice Series"), from the genetic code ("The Burning Helix" series) to the astrophysical ("Stellar Winds" and "Solar Flames.")

Throughout this broad range of interests, there is an internal consistency. Wayne has always had an analytical, even scientific aspect to her aesthetic. "I enjoy discovering a new bit of information and trying to figure out its implication." She remembers two exhilarating discoveries she had as a child of three or four, both derived from reading the comic strips one Sunday morning. "I noticed that the word 'in' and the word 'to' could be joined together to make a third word. That was a big deal to me. The second discovery was that the funnies were printed in color, and being nearsighted, I noticed that the images were made up of thousands of little dots, that the green was made of blue and yellow dots." This early experience established an enduring conceptual model. For the past several decades, Wayne's art has dealt with information systems and astrophysical space "because it is the new wilderness, the next frontier, a wilderness of an immensity we have yet to comprehend," asserts Wayne. "When we look at the stars, in fact what we see is lights that left their sources hundreds of millions of years ago—sources that probably no longer exist. By comparison, our concept of time is child's play, a single pixel in what Freeman Dyson refers to as 'infinity in every direction.'"

One of Wayne's recent projects is a group of paintings, "The Djuna Set," that deals with ambient light in space. "Djuna" is a word Wayne invented for its mysterious, evocative sound. The "Djuna" paintings are thickly surfaced panels, some metallic, some intensely colored, but all changeable as the daylight changes. They are elusive, sometimes seeming to disappear, other times scintillating like technological icons. All manner of optical and temporal consideration are called forth. Yet even as they puzzle, they seem familiar. The paintings relate to the process of knowing, being and cognition. Wayne says she is "referring to the kind of recognition that comes from seeing something you have never seen before, but recognizing it at once."

In her suite of lithographs titled, "My Palomar," a square travels across a rectangular field. "Palomar" refers to the observatory in San Diego as well as to our methods of seeing and recording astrophysical imagery. The squares and fields project three magnitudes that are variously juxtaposed. Each magnitude can be read as field or detail, as abstract or specific. Because scientific imagery has not yet become a familiar part of our visual inventory, the lithographs appear abstract at the same time they seem concretely—albeit poetically—descriptive. Wayne intends the ambiguity: She wants to make us question what we see, to make visible what we cannot see but what now is known to exist as specifically as does a tree or bone. Thus, she is as apt to "visualize" an electromagnetic field or a tidal wave, both of which she has explored in various media. But the poetry is intended as well. An adamant believer in the pleasures of the visual experience, she wants her images to "kiss the eyes." And they do, as elegantly patinaed surfaces shimmering in effervescence.
–B.A.B.

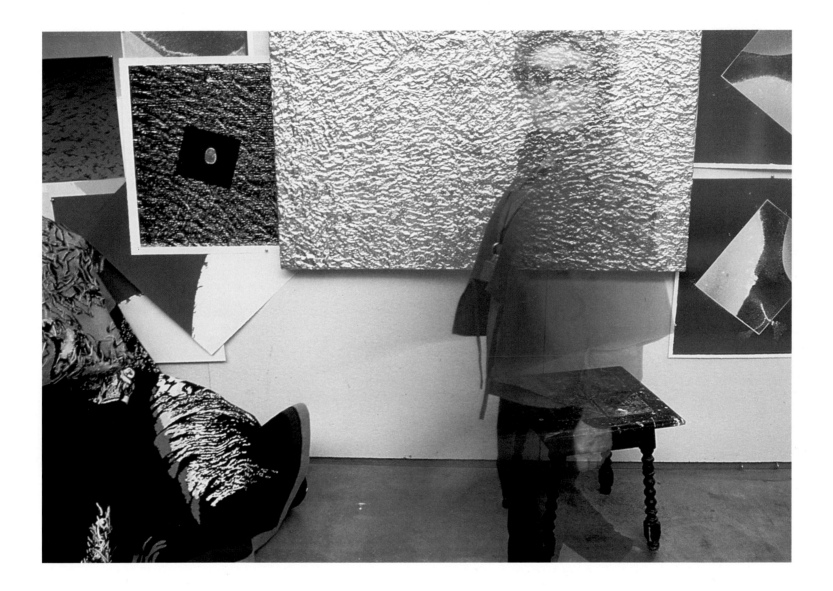

Melissa Zink creates small sculptural tableaux in which historic or allegorical figures interact with symbolic forms. Bertrand Russell's disembodied head, in cold antiseptic white, hovers over a spindly scaffold; a cone, a sphere and a cube dance around him. Letters evolve into fish, into figures, then back to letters; each metamorphosis is charted on the fractured planes of a carmine cross. Virginia Woolf becomes Lewis Carroll's Alice, meeting her father as the Mock Turtle, then screaming in terror at one of the birds Wolff heard again and again through her bouts of insanity.

Painters often constructed what they called "sacra conversaciones" (sacred conversations), in which religious figures from different historical periods, usually saints, were imagined together, discussing issues of theology and ritual. Zink uses ceramic and wood to portray the saints of our secular culture, and places them in conversation with objects and ideas. Many of the ideas she explores are literary. At other times, Zink explores philosophy. She is particularly interested in Nietzsche's assertion that any philosophical system is a function of the personality of the philosopher. Her tableau with the Bertrand Russell bust forces consideration of the personality of the philosopher who argued for such mental absolutes.

Zink is particularly interested in the myths of art history. She looks beyond a small reproduction of the famed portrait of Monsieur Bertin by French academic artist Louis J.A.D. Ingres to imagine the patrician's home life. In "Domesticity of Monsieur Bertin," the familiar stocky figure is turned into a seated humanoid with rhinoceros head. He gazes at two drawings of himself, done in the refined linear draftsmanship for which Ingres was famed. Between the drawings stands his wife, coy, demure, imprisoned in a wooden framework, also flanked by two drawings of herself. She has a human head, but in one drawing poses possessively with her infant rhinoceros.

Each of Zink's enigmatic tableaux combines ceramic figures (they average from four to six inches tall) with settings cut from wood. The clay and wood are fastidiously crafted, exquisitely painted, and each evokes the same sense of mystery and beauty. The small scale is important for the reading of her work. "Scale and time are related," Zink explains. "Scale can change one's perception of time. When I look at things much smaller than me, I enter a trancelike state." The mystery and beauty are important for Zink as well. "Most surreal art is not beautiful. I want to make beautiful magic."

Finding what she wanted to express, and discovering the medium to express it in, was not easy for Zink. Her Missouri parents thought the visual arts were "reprehensible." She was a shy child, but remembers summoning up the courage to go to paint stores and ask for out-of-date wallpaper books. She cut rooms from the paper, populated them with paper dolls, then began the next series of rooms. She also created her own fantasy spaces in the yard or at the park, under bushes, beside trees. As an adult, Zink studied art history at Swarthmore, married and divorced. She ended up in Silverton, Colorado, where she met her present husband, who she says "saved her life" by encouraging her fulltime pursuit of art. His support and encouragement were the first she had received for her art. In less than a year, Zink was exhibiting at a gallery in Taos, New Mexico.

Although Zink's early work is similar to her current work, she recognizes some transitions. "I was so enchanted that I could make anything that just the *doing* of it was consuming," admits Zink. "Now I'm more interested in the formal/visual result. Also, the early work came from a totally internalized fantasy. I would imagine myself in situations, involved with images evoked by words and phrases, then create a small environment for the situation. Now, I have a somewhat broader view of thought. I'm interested in the history of art, in relationships, ideas . . . my fantasy world has become more externalized." Explaining how her imaginary worlds take shape, Zink states, "It's like you're walking around with this enormous suitcase full of magic and you are never allowed to open it, because the rules say that the things in that suitcase are not worthy of artistic consideration. Words, childhood memories, pretend, fantasy, archaeology—all that. Until I could open that suitcase, I didn't really have anything to work with. It was like trying to paint with your hand tied behind your back."

The suitcase Zink opened contains a universe of adult figures who cover the spectrum of adult dreams, push up against the boundaries of adult sanity, juggle the golden apples of adult myth, traverse the difficult highways of adult resignation. Zink's art examines the arbitrary essence of our culture's systems and representations and, like the child in "The Emperor's New Clothes," recognizes they are only real within the Emperor's mind. It only takes some imagination, spiced with a little whimsy, to break free of them.–*B.A.B.*

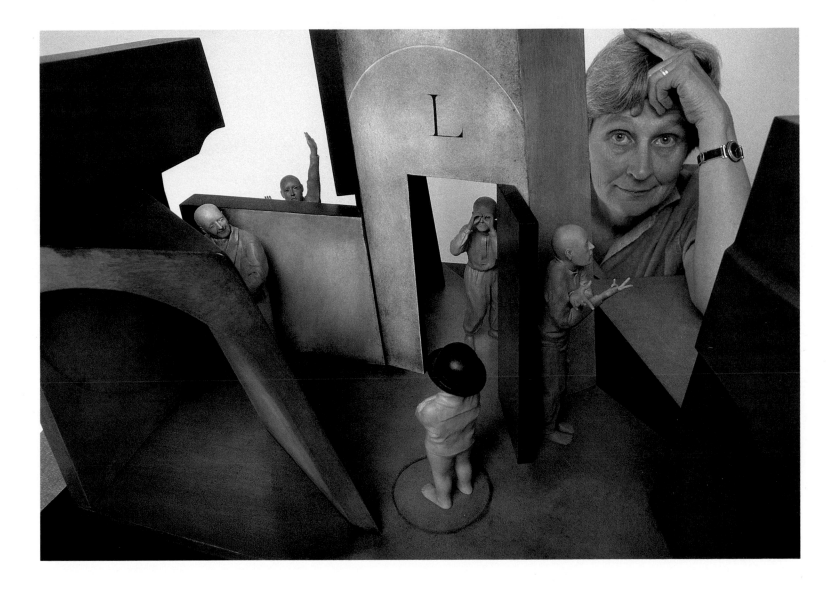

"I was an abstract painter in the abstract expressionist mode until 1970, when I returned to this country after eight years in Spain," explains Joan Semmel. "My whole life changed. Feminism brought me back to the figure." Semmel's figurative paintings begin from the most literal interpretation of female self-determination—the representation of her own body. Some of her most striking canvases depict a nude or semi-nude woman—larger than life, cropped at the neck, foreshortened in the extreme—as if each viewer were its occupant, looking down upon oneself.

"I began to draw and paint when I was 11 years old, but I didn't commit myself to art until my mid-20s," recalls Semmel. She attended the High School of Music and Art, and Cooper Union in New York City. "After Cooper, I got married and had a child," she adds. "Ten years later, I returned to school, attending Pratt Institute. I was a working artist, but I wanted to get a degree so that I could teach." Today, Semmel holds a full professorship in the art department at Rutgers University, with considerable authority as a professor and exhibiting artist. However, she points out that middle-aged women are at a disadvantage: "There are few mid-career women in gallery rosters."

Semmel's paintings reveal her training in rendering the human body as well as her assimilation of the traditions of Post-Renaissance and Mannerist Italian figurative painting of the 16th and 17th centuries. "When I allowed the nude to reappear in my paintings, it wasn't simply a studio nude," explains Semmel. "My erotic nudes of the early 1970s were my part of the sexual revolution and they were erotic from a woman's point of view." Semmel's erotic nudes were also revolutionary for an art audience accustomed to seeing female nudes painted by men for men. For her self-portraits, Semmel learned to take slides of herself while in a reclining pose. She made color copies of the slides and used these to construct collages as preparatory studies for her large paintings. "At that time the figure was a no-no, taboo, yet also considered passé and academic. But I had to do it," states Semmel. "This work was empowerment—women taking on their own sexual power." Even when Semmel's style evolved into a cool, super-real realism, her nudes still retained their eroticism. Her figures were aggressive because of their size, yet often passive in their poses; intimate in their closeness to the picture planes and the edges of her canvases, though threatening in their rejection of "feminine modesty." These painted women eloquently state the modern dilemma for female creators—are creative women desired objects or bold, powerful initiators? "Nude self-imagery was my most conscious and direct attempt to deal with my sexual- and self-definition," notes Semmel.

Self-analysis took a new bent for Semmel in the early 1980s when she created clothed self-portraits. Family expectations and the struggle to remain true to herself became cardinal issues for Semmel. In her "Self-Portrait on the Couch" (1983), Semmel's focus shifted from body to mind, from exposure of the flesh as disclosure to exploration of the psyche (even in psychotherapy on the couch) to build self-awareness and free the spirit. In the artist-subject's right hand are artist's brushes, along with a photograph of her father. Behind the couch is a standing nude portrait of her male lover. These factors draw the dilemma for Semmel between living in a patriarchal context and pleasing the men in her life on the one hand, and creating her work from a whole self on the other.

"Today things are more complex," Semmel observes. "I'm also a different age and my concerns have shifted." In Semmel's paintings of the past several years, she says, "I've moved off sexuality as the center of my subject matter. Although there has been a retrenchment in regard to sexuality—and I'm not in favor of it—there is some wisdom in no longer thinking that a free and open sexuality will solve everything." She adds, "I want my work to move people to feel what I have felt." Semmel's figures equate paint with flesh in a primary relationship, traveling between Eros and the self, the feminine spirit in the world. As a portraitist, she has been compared to Native American "soul catchers" and turn-of-the-century Western photographers preoccupied with capturing personal auras. Even in her most recent clothed figures, seen at a greater distance from her picture edges and in contemporary social situations such as exercise classes, Semmel courts empathy and identification rather than voyeurism or pictorial confrontation. At the same time, there is a challenge: "My new work explores isolation and narcissism as the social malaise of this time."–A.R.

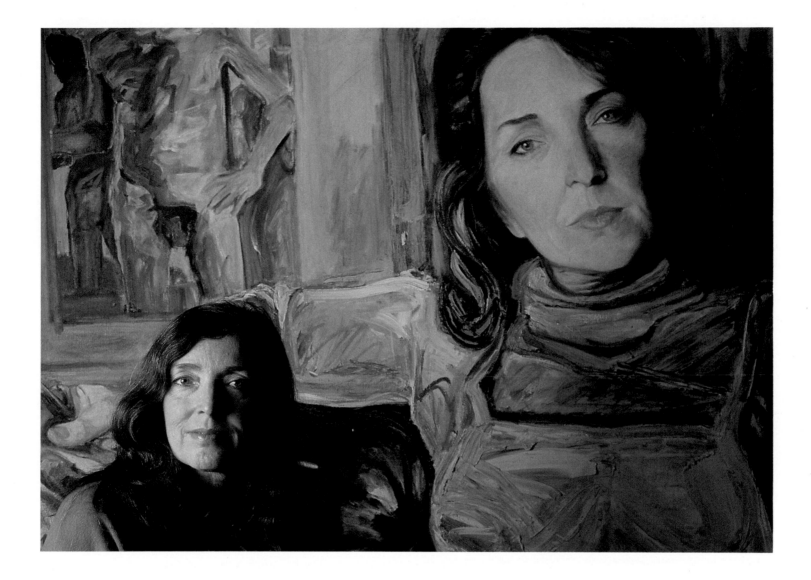

Jerri Allyn views rape and incest of girls as their first oppression as well as their first encounter with love and death. She puts forth her startling views, hard facts and difficult issues, drawn from her own life and her impassioned responses to world-wide injustice, in her multimedia artworks. "I was gang raped at seven," states Allyn, "and I'm not alone. Statistics say that one out of three women has been sexually abused. Most people don't want to hear it. For me, it's a challenging 'formal art problem' to find a way to present difficult information so that people *can* hear it."

Allyn creates original poetic texts she performs live and on audio and videotapes, media performances and mass actions, graphic arts and artists' books. Allyn does not consider her work as an artist to be defined by any particular media. She is a conceptualist who carries out her ideas in many different genres. "My main goal as an artist is to communicate," Allyn explains. "I constantly solicit feedback from artists and non-artists about the clarity of my stories. To me it is of primary importance that people are able to understand the words and rhythms. It is of secondary importance to add multi-layered experimental dimensions of voice and sound.

"When I wanted to build a New York audience after I moved here in 1981," Allyn recalls, "and asked colleagues how to do that, they told me that people wanted to hear the stories I was telling more than the experimentation." Allyn took her stories in her own voice to audiences wherever she found them. Diners having breakfast at Gefen's Dairy Restaurant in New York's West Side garment district in the fall of 1987, for instance, were in for a surprise. They didn't know that Allyn, once a waitress in the same restaurant, had turned Gefen's into her own theater; unsuspecting diners into participants and audience for "American Dining." "Name that Dame" placemats, with Allyn's four different designs, amused those seated in booths and at tables while they waited. From coin jukeboxes on the wall within each booth, Allyn's voice in wild registers and rhythms raged and cajoled her now captive audience about women and labor. Soon Allyn appeared in a waitress uniform at diners' tables, asking, "More coffee?" Allyn knows her subject, "waitressing," from the inside out. The Waitresses, a public performance art group she co-founded in 1977, boasted 14 years of collective waitressing experience. Allyn sees the plight of the waitress—wonder-worker, goddess, or wife—as "a metaphor for women and work, money, food, and power. I see the restaurant as a symbol for the world. How do you feed and house a soul with work that's important?"

Allyn's projects and performance pieces have been deliberately designed for public places and the use of public media for more than a decade. She has performed in such unlikely locales as Los Angeles City Hall and Malta's Ministry of Culture, as well as in demonstrations on city streets in the United States and Europe. "I collaborate with the audience," Allyn explains. "A working back and forth. But reaching more people also means being more accessible." When Allyn occupied the Spectacolor Board at Times Square with "A Lesbian Bride" during August 1987, her information for the largest possible audience—New York's public at large at Times Square—was different from other advertising. "A Lesbian Bride" was a tribute to her friends, Sue and Cheri, married in an alternative wedding ceremony. She explains, "I wanted to put forward the possibility of making a living commitment in the face of our ultimate mortality—by women, "queers," and people of color, whose commitment is trivialized and limited in American society."

In the Spring of 1977, Allyn mapped out a seven-day performance entitled "Cancer Madness." She turned her Los Angeles studio into a hospital floor complete with waiting area and gift card rack, stayed in bed for a week, and scheduled various health practitioners to demonstrate and lecture every evening for the public. "In 'Cancer Madness,' I exorcised my fear of cancer and madness," she explains. This self-healing ritual dealt with Allyn's concerned feelings about her mother who died from cancer when 43 years old and the peculiar "women's madness" of her 80-year-old grandmother, often confined in an institution. Moving "from presumed insanity to instead a logical reaction to an insane society," from the subject of personal health to foreign occupation, and from the first to the third person and world, is Allyn's evolution from autobiography to global politics. Though she may be plagued by both, she remains full of hope. "My mother's most profound legacy was her death," states Allyn. "I learned I could continue living—and laughing."–A.R.

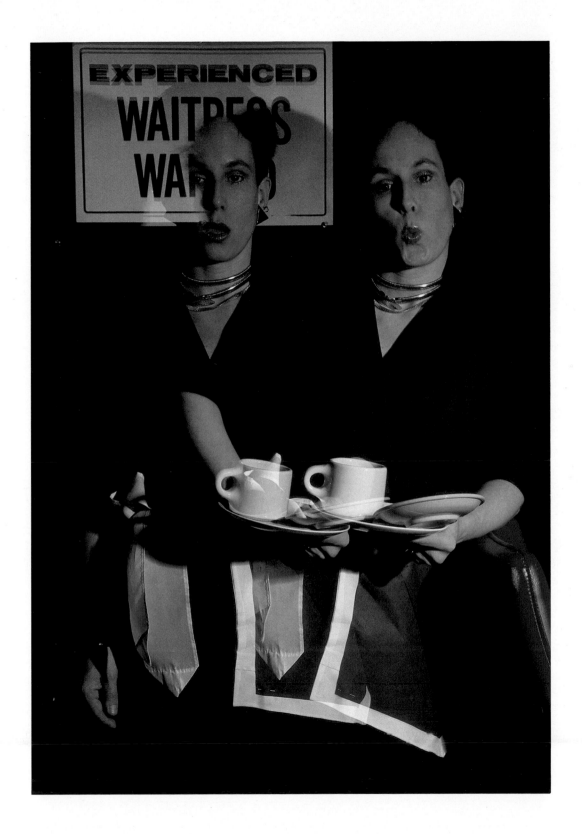

"The main idea behind my work is that there's this connective underlying theme that generates everything, all the diversity that's out there in the world," states Ann Page. Her artwork, like her personal biography, balances influences of East and West. She creates sculptures that recall Japanese kites, origami, the elusive poetry of Zen gardens, while at the same time relating to the avant-garde Euro-American traditions of conceptual art and minimal form. Her work seems to echo the Buddhist saying, "Heaven and earth are of the same source; ten thousand things and I are one." Her artwork also relates to Peter G. Stevens' analysis in "Patterns of Nature:" "It turns out that the immense variety that nature creates emerges from the working and reworking of only a few formal themes."

Page was born Setsuko Ann Takayoshi in 1940. Her grandparents were from Japan and her parents ran a "family business" grocery store in Seattle. Page's father was active in the Japanese community and her mother was interested in art, adorning the house with Oriental brush paintings and teaching the children origami. The Takayoshi family moved to Indiana after release from a World War II internment camp and Page lived in the Midwest until she was 24 years old.

Page dropped her first name Setsuko and simply used "Ann" in grade school in Indiana where, she recalls, she felt "totally different from anyone else in class." Names continue to be important to her. "I have this physiognomy that says 'Japanese,' but I'm third-generation American and was raised in the Midwest," says Page. "After my marriage, I used Ann Takayoshi Page for a long time, but it was too cumbersome. Ann Page says me in a lot of ways." Page attended the John Herron Art Institute of Indiana/Purdue Universities in Indianapolis. While there, she met her husband, artist George Page. It was also there that she had one of the "peak experiences" that significantly shaped her art. "While in art school, I happened to be looking out the apartment window to our backyard one day and Bach's 'Brandenburg Concerto #4' came on the radio," recalls Page. "It wasn't that it was preorchestrated but everything went together—the way the tail on the dog was wagging and the leaves on the tree were moving, the way a man was walking out the back door. Everything coincided with the rhythm of the music. It all seemed to make sense." There were other experiences, too. "I would be doing experiments with paint and these images would come out," adds Page. "Then I'd look over at a plant and it was the same pattern as my painting. So there is this definite order that runs through things that I'm interested in."

Page's drawings explore the unifying rhythms of life. She begins with basic natural forms—one of her first was a geometrically simplified popcorn kernel—and allows them to reproduce, almost organically, over her drawing surface. The forms act as modules in multiple compositions that develop texture, pigment, shadow. Page also creates sculptures in paper and wood and fiber. Starting with shapes like triangles or hexagons, or with shapes derived from pods or leaves or twigs, she generates elegant forms of fragile mass.

Page's work is related to minimal sculpture that developed in the 1960s and 1970s, sculpture that presented a unit or structure as part of an endlessly repeating grid in an unlimited universe. But Page has always been put off by what she perceives as the "coldness" of most minimal art. She reacts negatively to the austere geometry, to things that are manufactured in multiples, without individuality. Page prefers the work of artists like the German Eva Hesse, who took things that were ostensibly alike but showed their dissimilarities. "I've always been a big fan of nature," says Page. "The idea of repetitious structure came about by looking up at leaves and realizing, yes, they were all leaves but they weren't the same shape. I also looked at clouds a lot and came to similar conclusions. I am interested in the individual rhythm displayed through repetition, the individuality that comes from one unit being repeated several times then changed."

Although Page studied Western art at the Herron Institute and in her earlier schooling, her current work clearly manifests an affinity with Japanese traditions. "When Japanese slides would come on the screen in art history classes, I'd think, 'Those are flat and decorative, I don't really like those at all.'" She adds, "It wasn't until I went to California and was looking at some patterns on Japanese kimonos that I recognized how really great they are. At that point I'd already gotten into repetition and pattern and was beginning to appreciate it. Also, there's a lot of vegetation in Los Angeles that has repetitive structures that become very prominent because the sun is bright and shadows are strong. All these elements started to dovetail."

Recent works by Page are mixed media constructions that combine the crisp, rigid forms of plane geometry and the biomorphic irregularity of nature. Straight, graph-like lines fold over the petal-like edges of ripped, wrinkled paper. Numbers and angles lay over leaves, branches and tree bark. Page continues to combine the structure of Western culture with the poetry of Asia.—*B.A.B.*

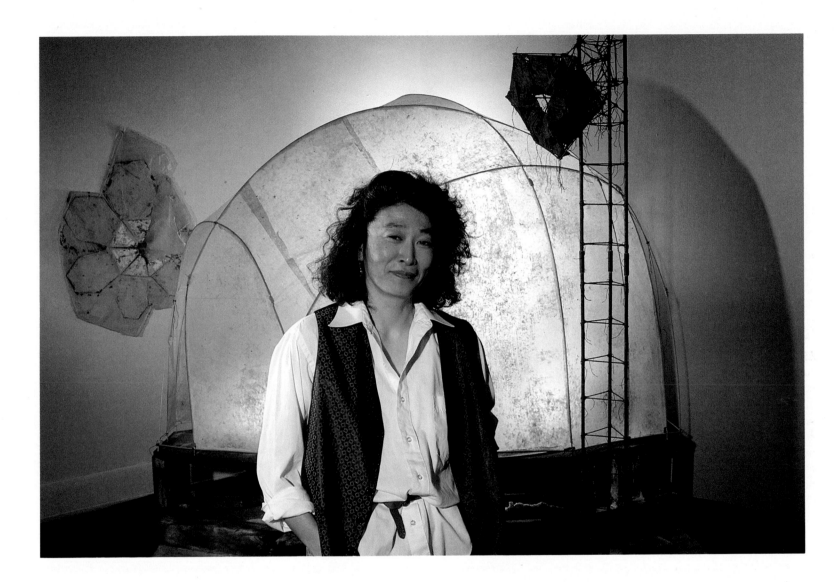

"I think that art is an internal investigation of who you are, what motivates you," states Jean Edelstein. "It can't be something out there, it has to be something totally inside." Edelstein looks if not otherworldly, then at least of another time or place. The priestly cast of her black clothes is heightened by the halo of her silver hair. She speaks of her spiritual life, enchanting the listener with her ardent intensity.

Edelstein's involvement with things not of this world seems an ironic reversal of the directions promised by her youth. The daughter of poor and outspoken Marxist immigrants from Rumania and Poland, she combined her early work as a fashion illustrator with social activism. She moved to Los Angeles in the 1940s, married another artist and had two children, who also are artists pursuing art careers in New York. Today, Edelstein lives with her husband, Sy, in the Venice Beach studio/home they designed.

Edelstein might still be combining art, commercial art and political action, if it had not been for a pivotal experience she had on a trip to Israel. As she explains, "Jerusalem is really spectacular, especially the light. You almost feel there's another presence there just because of the light. When I went to this tiny town of Safad, which is up on a hill, I suddenly felt—and it was the first time I'd felt anything like this—that I had been there before. We went to Safad to see the Lag b'Omer ceremony. For this ceremony, the townspeople paint the doorways and streets a bright deep-turquoise blue. Then they take the Torah to the other side of the mountain and bring it back that evening. The men dance in a circle around the Torah and carry each other on their shoulders. The women walk after them trilling their voices. My husband and I participated, going house to house with them. For some reason, they felt very friendly toward us and as we walked toward the synagogue, they gave my husband the Torah. I was overwhelmed and I fainted. Something happened . . . I really don't know." Edelstein continues, "Afterward I kept dreaming about a Shakina (a female spirit) and I realized there are so many unknowns. What we see is just what our perceptions permit us to see. That experience in Safad opened up another world to me. The 'Temple Series' in my artwork came after my trip to Israel. It reflects the light, the iridescence." Edelstein's "Temple Series" is a group of large hanging scrolls with doorlike rectangles framing central bar forms. The painted surfaces are textured with layers of elusive, gauze-like patterns, which shimmer in cool, meditative tones. They are incandescent icons for prayerful focus.

While Edelstein had done figurative work before and during the "Temple Series," it was not until she was serendipitously reconnected with her model and collaborator Camille Bertolet that her current painting series emerged. Bertolct is a gracefully athletic woman, an acupressurist who, like Edelstein, explores spiritual realms. As she and Edelstein began to work together a second time, Edelstein felt she was continually seeing images, movements, poses that were reminiscent of the frescoes of ancient Crete, especially the site of Knossos. "It was so strange! I didn't know why Camille and Crete went together but after a year of seeing that, I decided to do research on the Minoan culture," explains Edelstein. "That's when I realized there was a thing called the Goddess. My Marxist background certainly didn't prepare me for the Goddess! Then everything I had been doing finally came to fruition—my work became a temple for the Goddess."

The "Goddess Series" includes both paintings and painted sculptures of lithe women dancing in glorious acknowledgement of female power. It is the product of a unique collaboration. "Whenever they talk about a male artist and his female model, they always talk about her as if she were something less, an object, something there for his satisfaction, not an individual who is really working with the person," notes Edelstein. "I feel my working relationship with Camille as a model is a totally different experience—two women working together." How they work is also important. "We both work in trance states, getting to another level of consciousness through intense meditation. We don't take drugs, we don't take alcohol to get there. It's a sharing." In model/collaborator Bertolet's words: "Jean is a dancing, skipping child. She is a tenacious, determined, single-minded athlete; pious, forceful and psychic, yet tough and resilient."

Edelstein's more recent body of work delves into the more primal earthbound dimension of female spirituality. Bold, heavy forms gather and rise out of crowded, crouching stances, then turn to generate tremendous and mysterious power. Faceless, hairless, naked, they evoke the eerie presence, the hushed chalky tangibility of Japanese Butu dancers. Their thin, pearl-like surfaces seem hints, poetic allusions, faint echoes, rather than statements. They resist erotic consumption by the viewer, yet remain both physically and sensually present. –B.A.B.

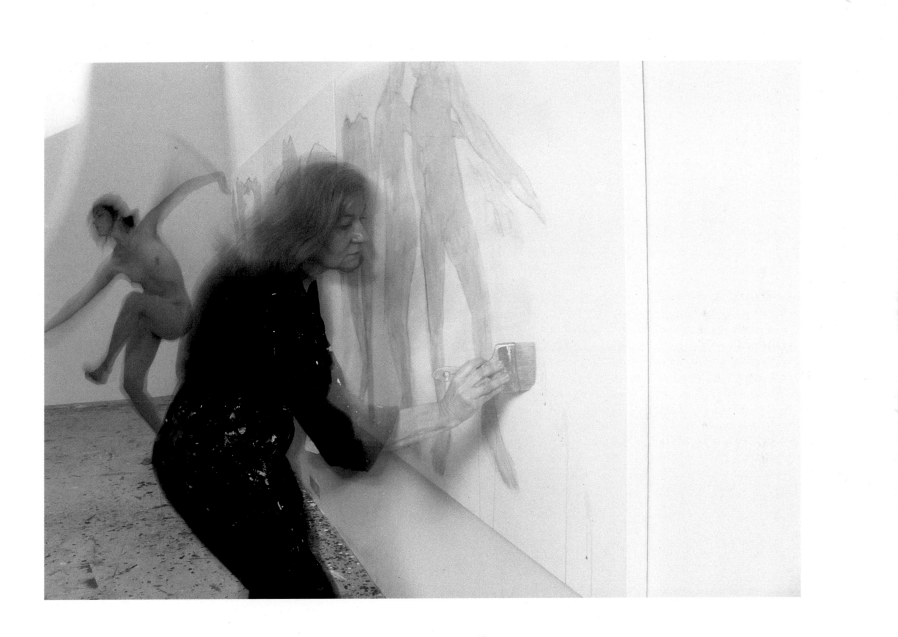

"I think it's kinda hot to have one breast," states Nancy Fried. "And I love sculpting the scar. It heals." Fried tells of a curator who, during a studio visit, called her torsos "androgynous." He saw a combination of male and female—one side of the body with protruding female breast, one with flat male chest. "I think he saw the slash across the chest and the absence of a nipple as my chosen level of detail, compatible with the schematic hands and undefined fingers of many of my figures," observes Fried. "But I cannot help but believe that he denied what he saw."

Always a mirror of her own history and psyche, Fried's figures have always been literal presentations of her personal circumstances, reflecting social and political implications for many women. Her most recent sculptures are modest and undecorated, conventionally modeled fragments of female figures. Their conventions are deliberate. The draperies, poses, surface colors and even clay material recall Greek, Roman and Mesopotamian figures as well as Renaissance adaptations of classical art. They point to the beginnings and subsequent "classics" of a two-thousand-year-old sculpture tradition. Her faces can be "read" as an allegorical narrative of emotions—a Greek tragedy—ranging from a mask-like smile to pained rage to simple grief. Handsome cylinder-like heads can be seen as tasteful contemporary adaptations of the antique . . . until you see the backs of the heads. On the back of one head, two breasts can be viewed through the top via a cut section. In another, a tumble of breasts replaces the entire rear covering of the head. A third shows a scarred torso lodged in the circular stage of the cranial interior, above the inscription "In Memory of 1986-87." This marks the time of Fried's cancer surgery, resulting in a mastectomy, and her creation of 12 works that enshrine her loss and embody her regeneration.

A one-breasted terra cotta torso titled "The Hand Mirror" (1987) seems to have let her mirror drop below her skirted waist to show us what she has been looking at. There is no head, but still the sculpture is not missing a face. The "face" is the chest, where the viewer is face-to-face with a female figure never before seen in sculpture. An incised diagonal extends from the right edge to the center of the chest and disappears under the left breast. Fried's sculpture celebrates biological reality, including the fact of her mastectomy, without sensationalism or regret. At least one in every ten women has had breast cancer. Fried's perspective comes to terms with the female body as always changing—the transition from puberty to pregnancy to post-menopausal femininity, including the possibility of a flat mastectomy chest and protruding, scarred belly, as a fact

of physical evolution. Fried's sculptures offer a refreshing standard of acceptance and respect for the truthfully rendered bodies she portrays. For Fried, fashioning her heads and torsos "makes me feel attractive again." Yet she rails against the "normality" for mature women to lose breasts and uteruses to cancer as a medical and societal abnormality. Fried's sculptures with their facial howls and grimaces, shrinking, grieving and defiant postures, and her construction of memory walls and shrines, give full expression to Fried's journey through these complicated life- and self-endangering circumstances.

Fried created her first artworks in 1975, making dough works of small medallion bas-reliefs, baked in the oven as gifts for friends. Her dough figures were women set in their everyday lives—playing basketball, bathing, working, making love, alone or together—and all alluded to the larger community of the women's movement of the 1970s in both its public and private realms. For more than a decade Fried developed her art while living in Los Angeles and participating in the art community of The Woman's Building. When she moved to New York in 1980, her dough medallions grew to become small clay dioramas, two- and three-dimensional stage sets and finally, sculptures fully in the round. Fried painted her surfaces and at the apex of her impulse to decorate, her small precious objects resembled persian painted miniatures or rugs. A few years into the 1980s, Fried left her clay entirely without adornment, her surfaces drying to the varied reds of terra cotta. "I no longer needed the beautiful, protective covering," Fried notes. "I could be completely plain and honest."

Fried breaks a taboo of "face" by showing a figure in her own image, a woman with a mastectomy. "Everyone's keeping the secret, like rape or incest. They want to spare other people. But I decided, I come first!" Fried challenges every convention of idealized woman—from Greek goddesses to Renoir's ample nude bathers to Elvira Bach's athletic amazons—ever made in the history of art. –A.R.

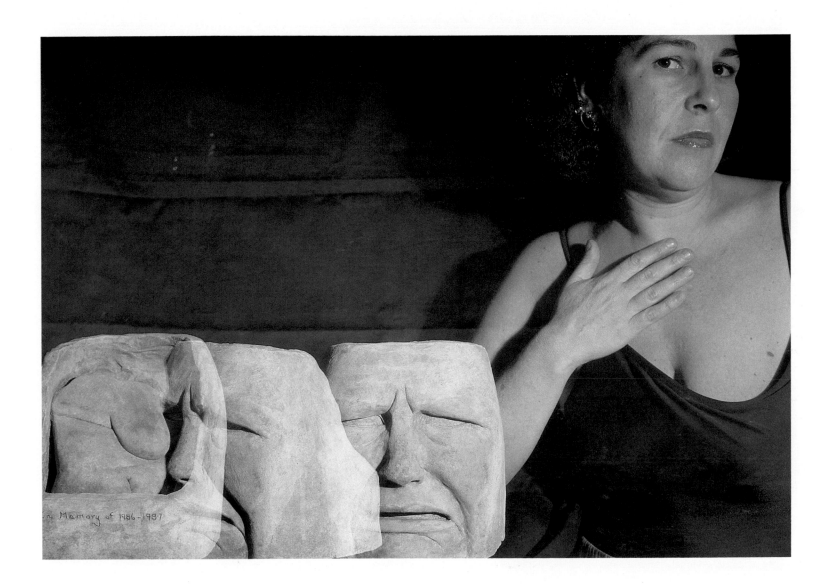

In Memory of 1986-1987

Betye Saar collects things. She searches through antique stores and swap meets, through other people's refuse, the attics of aunts, the garages of friends. Her daughter Alison, an artist, sends her things from the streets of New York. She receives other objects anonymously in the mail. Saar travels extensively to broaden her inventory of material culture, and often invites gallery-goers to add their things to her altars and installations. "I have always been attracted to things—objects, discards, found materials," says Saar. "I like to combine them and transform them into assemblages and collages. This recycling gives my work power, by changing the previous use into another kind of information."

Saar stores her amazing potpourri in the myriad boxes and drawers that line her studio walls. Inspired by a trip or a dream or a movie or a political event, Saar collects a few of her things, arranges them into a box or altar or room-sized environment, and magically transforms what other people might consider junk into visionary artistic statements about herself and her world. She glues her things together, paints them, draws on them, breaks and reconstructs them. The metaphoric power of Saar's work comes from the clustering together of things not usually related. Her unexpected combinations can be unsettling; they are often poetically beautiful.

Saar grew up in Pasadena, California, but spent her summers in Watts, located in south central Los Angeles. When she went to the market with her grandmother, she walked past the Watts Towers, now a folk art landmark, that was built by Italian immigrant, Simon Rodia, over many years. He piled up the cement, bricks and rocks that make up the towers and covered their surfaces with a glittering mosaic of tiles, bottles, pottery shards and the angular forms of his railroad tools that were pressed into the still malleable cement. The Watts Towers made a "big impression" on young Saar. "I was a kid who was fascinated by fantasy, by fairy tales and things of the imagination. The Towers always seemed like a fairy castle to me."

The influence of the Watts Towers was not apparent in Saar's work until the late 1960s when, after pursuing undergraduate and graduate work in traditional printmaking, she was "turned around" by the artwork of Joseph Cornell. She was inspired by his tiny boxes filled with images from old books, crumbling leaves and bent twigs, alchemical tools and formulae, the aristocratic artistic icons of European history. Saar remembered her childhood collections of things found in the dirt—shells, rocks, buttons—things she later placed into boxes. The boxes enclosed special treasures that had secret meaning for her. She also remembered the Watts Towers. "When I saw Cornell's things, they gave me formal *art* approval to incorporate the images and processes of my childhood into my work," admits Saar.

She began to mine potent images of the past—of mysticism, palmistry, astrology—and to weave them together with objects from Africa, Egypt, Oceania. While in the midst of exploring such metaphysical themes, she was engulfed by the anger and pain of the Civil Rights Movement, especially after the death of Rev. Martin Luther King Jr. She investigated derogatory images of Blacks in her art with her piece, "The Liberation of Aunt Jemima" (1972), which exposes what Saar saw as the cliched limitation of such a racist and sexist advertising icon. Saar found herself collecting old photographs of Blacks, repeatedly dealing with aspects of Black nostalgia. She also became involved in the Women's Movement in the 1970s. She was invited to curate an exhibition of work by Black women artists at Womanspace Gallery, but was appalled to see only a handful of white women among the several hundred who attended the opening reception. "So I said to myself, 'Does feminism mean white feminism?' It was like being invisible all over again." She finally realized that many people would see the exhibition after the opening night, so it would have a larger impact than she first thought. She also realized that her presence was needed in the movement. "I participated in the Women's Art Movement because I felt that if I have to be out front, then I have to be there. Otherwise we Blacks are totally invisible; and I still feel that way."

Saar's most recent work focuses on future images, which she sees as both autobiographical extensions and mystical predictions about the earth, environment and human spirit. She labels her recent art "visionary" saying that it often deals with dream time and that it has that quality of reverie, of that moment "in between." Saar seeks to make her art transcend the specifics of gender or race that would tend to stereotype it. "All I can do is make art that moves past those limitations and is more about the planet, more about universal themes."–*B.A.B.*

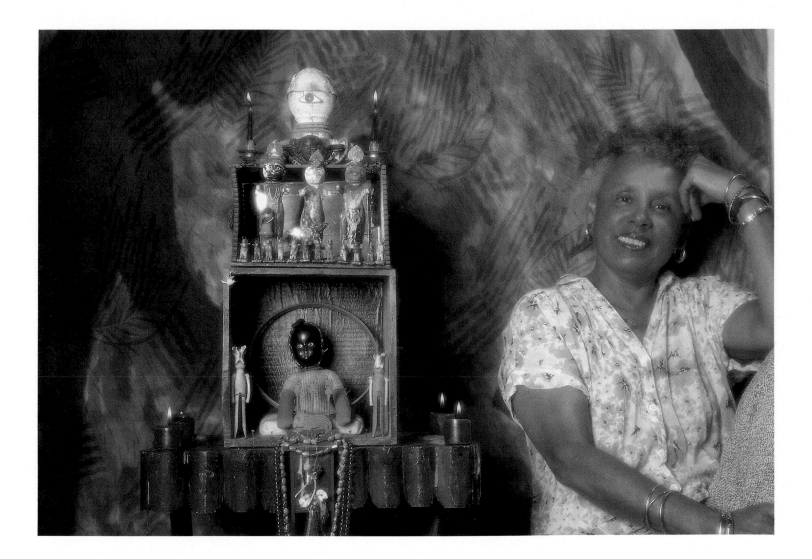

Surrealism is an artistic movement that initially coalesced in France in the 1920s. It was there that poet André Breton and his fellow writers, choreographers, musicians and other artists sought to depict those realms recently uncovered by Sigmund Freud's analysis of the unconscious. They endeavored, according to Breton, to make manifest that "certain point for the mind from which life and death, the real and the imaginary, the past and the future, the communicable and the incommunicable, the high and the low cease being perceived as contradictions." Carol Neiman is a contemporary surrealist. Breton's words could serve as a canny description of the mental states depicted in her complex and often unsettling compositions. Neiman's paintings are explorations of her own conscious and unconscious realities, portraits of her dreams and her fantasies.

Neiman was born in Oak Park, Illinois. Her father was a successful doctor and her mother a musician who played their grand piano throughout the night, composing symphonies that echoed through the vaulted ceilings. Neiman has a strong visual memory from before the age of two. "I didn't block out my childhood because I always had pictures," says Neiman. "I remember the first time I ever drew, because although I was sitting up, my head was so close to the floor. I remember the feeling attached to drawing: I had some place to 'put my stuff' after that."

Neiman thought of herself as an artist, even as a young child. She won prizes for her art and was asked to paint the Madonna for the school nativity scene, giving Mary shiny red lipstick. Neiman recalls one burning memory when she was six years old and took a drawing class at the School of the Art Institute of Chicago. The teacher gave the class an assignment to draw "Mary Had a Little Lamb." Inspired by Joan Crawford movies, Neiman depicted Mary in a strapless gown with large breasts and deep cleavage. This Mary, like Neiman's Madonna, also had long eyelashes and big sensuous lips. Because Neiman couldn't easily bring forth the image of a lamb, she instead drew a soft curly dog with a pink leash and bright bow. "That teacher took my drawing and held it up in front of the class and said, 'This is not "Mary Had A Little Lamb!" Mary was a little girl!' I didn't say anything, but I knew she was telling me to illustrate, when I was actually drawing," asserts Neiman. "I knew mine was a damned good drawing. Humiliation is meant to shrink the ego, but what it did to me, because I knew I was right, was it enraged me. When my mother came to pick me up, I said, 'I'm never going back there!' . . . as if I were 30 years old and had made a career decision."

In the early 1960s, Neiman moved to Los Angeles with her physician husband and enrolled in the University of Southern California for a master's degree in art, intending to teach. However, she never pursued a career as a teacher, because she soon became a mother, first with a daughter and then with a son. Almost immediately, Neiman began to experience motherhood/career conflicts. "I had thought that when my children were grown—the youngest say 15 years old—I would get a studio outside my house," explains Neiman. "But before my son was even two, I found myself becoming more and more anxious and upset. Finally, in 1969, I realized that I couldn't wait any longer—I needed my separate studio space." Ten years later Neiman found herself at another psychological impasse. "I was freezing up inside," admits Neiman. "I had to make a choice between my marriage and my art. I chose art. Even with all the struggle and pain of making art in this society, I realized I had this talent, this capacity. Art was such a pleasure, so satisfying and so rewarding—among all the banality of living— that I felt I got more from art than from anything else."

Neiman employs a variety of media for her surreal expression. She does large oil-on-canvas paintings, using the arduous technique of many-layered glazes perfected during the Renaissance. She also uses photography and color photo copies. Most recently, she has begun to explore computers as tools for generating and manipulating form. Her images come from both internal and external stimuli. A dream of Death as a bicyclist may initiate the composition of one of Neiman's works, or the shadowed face of a homeless woman haloed by a beachside street light. Neiman laments that her external stimuli seem fewer lately, but her dreams remain rich and evocative.

As in dreams, her works often balance unexpected juxtapositions with distortions of light and ambiguous, even warped space. Monsters leer. Children stand vulnerable, isolated before untouchable adult ideals. Sexuality is a specter. Social expectations are reversed. This is not to say Neiman's work is somber or depressing. Her canvases and photo copies are suffused with luminous color. Both people and objects are attractive. However, they are not controllable by reason. In all their power, they remain enigmatic, elusive . . . like dreams which, though evaporated at dawn, still haunt the dreamer. –B.A.B.

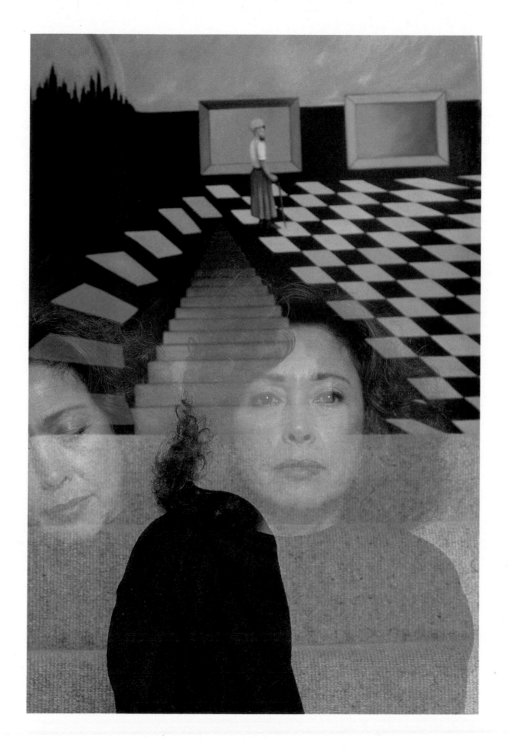

"I am following my progress with my own psyche," asserts Laurie Pincus. "I'm very involved with investigating it, not uprooting it, but allowing the child part to continue to play there, and help tell the tale." When Carl Jung wanted to get back in touch with his childhood, he started creating sculptures in stone. Pincus has never gotten out of touch with her childhood; her sculptures are part of a direct continuum that began when, as an infant, she separated her crayons into male and female characters and made up stories about them. Today, the characters range from hand-held to life-size, but they are still crayon-bright in color, and they still move through worlds generated by Pincus' imagination.

These worlds are fantastic—a slickly attired man carries a silver fish like a gun, a woman wears an ocean liner on her curly blond head—but they are always based on reality. They have the naivete of a child's vision, but the haunting truth of social commentary. Pincus' most recent body of work, "The Somnambulists," illustrates this point particularly well. A full cast of modern archetypes parades blindly before a dreaming self-portrait of the artist as adolescent. They walk asleep, in passive acceptance of quiet discomfort, deferring awareness to an unattainable future. Each character is both engaging in its brilliant visual appeal and discomforting in the distilled profundity of its satirical, often sinister, depiction. Among the cast of Pincus' repertory group are "Mr. Right," who has five women always looking for, but never finding, him and the "Other Woman," although the viewer is never quite sure which of the women depicted is the "other."

Pincus' first art memories are of drawing her interpretations of what she had seen on television or what her mother had read to her from books. She unrolled shelf paper and made elaborate scrolls, or cut the paper into little books. She also made up pictures to accompany the classical music her grandmother played for her. Her grandmother would then sit at the typewriter and type the descriptions Pincus dictated. In retrospect, the artist realizes both experiences were based on seeing the world, taking it in and bringing it out as narratives. Her artwork as an adult involves the same process. "It's definitely a continued connection for me," states Pincus. "I didn't stop and look back—I just found something early on and sustained it." Indeed, the only break in this continuum occurred in Pincus' college art classes, when she realized her art didn't fit into the context of what was being taught at Sarah Lawrence. "So I'd go home at night with a notebook, where it was real private, and the art would continue there. But it wasn't happening in the 'how to be an artist' world; it went underground for a while."

Pincus cuts characters from wood, covers them with brilliant acrylic patterns, and places them in settings that are both familiar and unsettling. A superficial reading of her sculptural tableaux might equate them with paper dolls, or with cardboard cut-outs. Since the images are seductively attractive, the viewer is frequently drawn to further consideration and finds intriguing psychological insight behind the apparently innocent vision. Lovers embrace, yes, but they stare blankly over each others' shoulders. They stand in a tiny boat that threatens to topple into curlicue waves. An adolescent girl dreams in her bedroom, her black dog crouched at her feet. Then the pet becomes a threat, a nightmare, a dark nocturnal emanation.

The source of many of Pincus' images is autobiographical. "My dogs sleep on my bed; they have since I was a kid," says Pincus. "I dream about dogs and how they represent animal instincts. There's also the dog in mythology who takes you into the underworld and helps you make the crossing. This is a magic time, when you go into the dream world." Yet Pincus' images are also universal. The dreamer could be anyone; her fears could be those of any youth. One reason Pincus was allowed to continue her childhood play as a youngster is because of her father's attitude about creativity. Mr. Pincus was a designer for theater and film, and worked at home. "His world was an imaginary world, the boundaries between fantasy and reality weren't clear," notes Pincus.

Today, Pincus' work unites fantasy and reality. As she bridges the two realms, trying to make the invisible visible, she gives form and substance to the imaginary world inside her. Because Pincus often shifts scale radically, viewers are forced to become participants in her art. They become Alices in her Wonderland of painted wood. "I like to use a range of sizes so that viewers are constantly adjusting their perceptions," explains Pincus. "Looking at the small characters in my miniature worlds allows for a sense of concentration and distance; viewers wait like toys for human relationships/connections to bring them to life. Then, when the same viewers walk into a lifesize version of this world and begin to literally rub shoulders with the characters, they find themselves actually inside the artwork. This is very exciting for me," adds Pincus, "because I have really connected one world to the other —I have brought my imaginary people into our 'real' world as well as bringing real people into my imagination. That is what my art work is all about."–B.A.B.

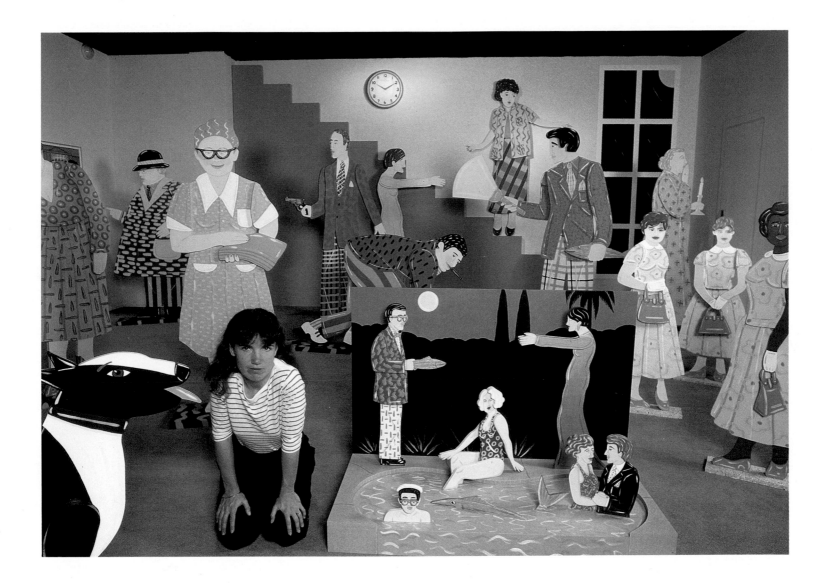

In the summer of 1987, Kathryn Jacobi traveled with her new husband to meet his relatives in New England. One afternoon, while paging through a family album, she came upon a photograph that had a peculiar resonance for her. The photograph portrayed an elderly woman sweeping the snow off the front steps of her clapboard home. The woman bore an uncanny resemblance to Jacobi's grandmother, whom she'd never met but known only through images in similar family albums. She also looked like Jacobi has always imagined she herself will look when she ages, so the photograph became a kind of projected self-portrait.

Jacobi brought the photograph back to her Los Angeles studio and began a series of paintings that explore the densely layered significance of that weathered but radiant image. "The woman sweeping became an almost perfect emblem of time, and I'm always concerned with time," explains Jacobi. "It struck me how sweeping off the encroaching snow became sympolic for holding back mortality. I started playing with the image and working with a number of settings for it and realized that while some of them did depict snow, in others I had started painting red—she was sweeping fire, too."

Time and mortality are the major themes in Jacobi's work. "As I understand it, the theme of the 20th century is time and its permutations." notes Jacobi. "One of the important functions of the artist at this point in history is to create symbols of continuance. Religious messages have become unsatisfactory for most of us, leaving us with a void in our experience of life continuing . . . I think that is why images of children, images of people in general, are so compelling." Indeed, most of Jacobi's paintings are portraits, images of her family, her mother, herself. They are haunting portrayals, fascinating yet frightening. Fragile, vulnerable individuals are suspended in dark, eerie spaces and captured in the smoky shadows of time. Their very individuality conveys a tangible mortality that is often painfully confronting. Caught in blood-red light, their chalky faces float before velvety umber voids.

For Jacobi, there is a risk involved in doing a portrait. "It involves an alchemy, an attempt to make something that will have a life of its own," explains Jacobi. "The artist becomes a medium for that to happen." Often, Jacobi portrays babies. "The reason I like painting babies is the poignancy of the particular moment. Two weeks later, they're a different entity. You see the march of aging so much more keenly telescoped during that time than at any other phase in a person's life."

She entitled a series of paintings of herself as a baby "Dwarf in a Tall Man's Closet." "I read in Leslie Fiedler's book 'Freaks' how people tend to project their dreams, fears and nightmares onto what society calls 'freaks,'" explains Jacobi. "Each of us has an image of our secret selves, an image that has mythic proportions. I had always been empathetically connected with dwarfs; it was an image I'd always carried of myself. Then I found a photograph of myself in a family album. I was six months old and I had the dwarflike face and proportions I'd always envisioned. So I had to paint it." Jacobi did a series of 10 paintings in 1987, repeatedly trying to come to terms with that image of herself as a dwarf/baby. In many of the paintings, she places herself in a closet with hanging shirts. The shirts imply the presence of her father with whom she had her strongest and earliest attachments. The portraits are dark, lit by veils of maroon light. The dwarf/baby emerges from a shadowy haze to gaze at the viewer with wise and serious intent. It is clearly a creature from another time and space—and yet Jacobi is recognizable. Her self-portraits are an avenue for recognizing or "re-knowing" herself.

Jacobi says she began working with photographs, particularly with photographs from old family albums, in "an attempt to understand the passages of consciousness, memory and culture." Moved by the unsettling power of images from her heritage, of a world that no longer exists—the Jewish culture of pre-Hitler Europe—she was driven to explore it through art. "My people's history has been blown to smithereens," states Jacobi. "I could not and cannot come to terms with that idea. I am appalled that holocaust is a possibility of human behavior. I know that it exists as a part of my own possibility, but then, time can be a holocaust in itself. These days I rarely look over my shoulder for the ax to fall." Jacobi adds, "I do have an awareness of the fragility of life, an awareness of the incredible sweetness of every moment of existing in good health and good condition. I take nothing for granted. I try to capture what comes alive while making a painting, so it will live for somebody else; live and and tell the truth."–B.A.B.

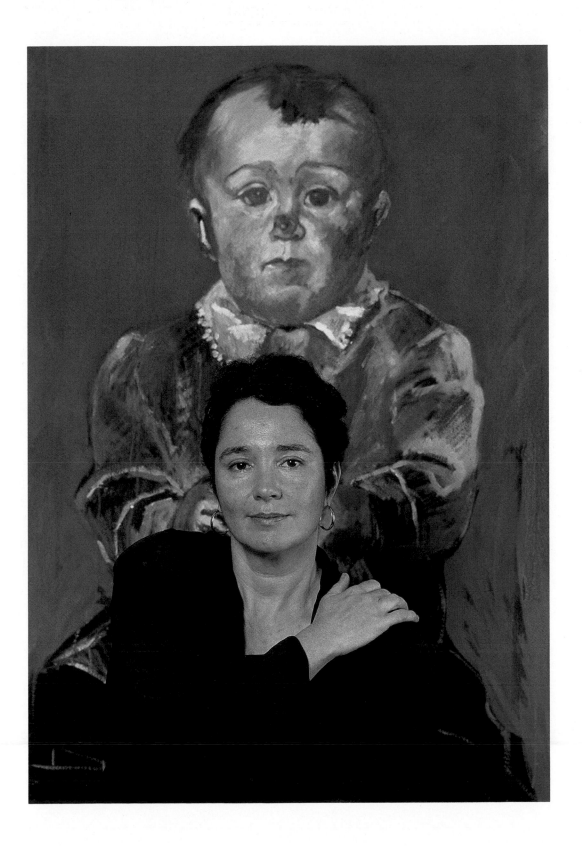

Phyllis Bramson's magical, theatrical images are psychological investigations of herself and her world—two realities that she feels are often out of sync, often dysfunctional. "I've always done work that reflects my psychological state and a gut reaction to the world as I perceive it—those are the most important things," states Bramson. "I deal with ideas I have about being an artist and how I relate to the world. My work has always been about disharmony and the desire to right things, about the struggle to make things work. That's the way the world is—it functions and it doesn't function. I function and I don't function."

In one canvas, an elegant brunette—not unlike Bramson herself—stands next to a man dressed in an absurdly patterned business suit. The woman wears a dunce cap; the man is blindfolded. Eerie, artificial light turns their skin magenta, then chartreuse. They dangle doll-like shoes beside them—the man's are sparkling high heels, the woman's are conservative male oxfords. In another painting, the same woman, now in a shimmering evening gown, bows to a man in white dinner coat and red tights. Her head is turned away from us, toward him. Her gesturing arms become red twigs, almost touching a yellow branch that springs from between the man's feet. He wears a thin, silvery mask and tenuous antlers. The woman and man are frozen in their awkward stances above a velvety dance floor. Other couples, glued in eternal embraces, look askance. Behind them, in a pastel room bent all akimbo, a faceless man pours water over two toy-like swans. Bramson has opened a window to an uneasy world, to her odd, out-of-kilter but strangely evocative dreamscape. That dreamscape occupies a skewed stage; each player is a distillation of the often-disturbing, often-conflicting components of her psyche. Bramson's pictorial space is frequently framed by curtains. The lighting is artificial. Even her landscape references seem more like stage sets than natural environments.

The theatricality of Bramson's work seems to have been fated. Speaking of her childhood, she says, "I've always been an artist, there was never anything else I was going to be. If there had been anything else, it would have been the theater. I dabbled in that, but as a child, I never could discipline myself to remember my lines properly. Nor could I rid myself of a feeling of inadequacy while acting. I did a lot of strange things when I was on the stage, so I set myself up not to go into theater. It took me a long time to realize I was still dealing with theater in my art. Now, when I go to the theater, I watch how the lights flash on the figures. I focus on the reality of the people juxtaposed with the artificiality of their environments. And when I do my art, the figures are real but the backgrounds are symbolic environments meant to contrast or to add on or even to abstract."

In dealing with the lack of harmony in the dysfunctional worlds represented in her work, Bramson takes the position of voyeur. "I've always lived a very safe life," admits Bramson. "I'd rather watch it all happening in my paintings. To me, making art is a difficult, intense activity where I can do a lot of things I wouldn't do out in the world. It's an area where I can function on a dangerous and erotic level. I'm sort of watching myself do it. The safety net often becomes the formal need of making a painting work."

Referring to her images, Bramson insists, "These are not just about male/female relationships. They are more about the male and female within each of us, about yin and yang, intelligence and emotion, rational and irrational thought." Bramson is uncomfortable with feminist interpretations of her work; she considers a feminist stance often too confining. "I feel strongly that as an artist, I'm not really male or female, but I'm more androgynous. The feminist issues have more to do with how I live my everyday life. The old guard feminists are interesting to me, but I want to be known for something else, for being erotic perhaps, or eccentric, or peculiar. I think there's a lot of powerful art that has a dark side to it. When artists project that, the work gets very potent. The artists put themselves in a vulnerable state and the audience may reject the ideas projected."

This vulnerability, this tapping of the "dark side" is not easy for Bramson. "There's something very existential about my work. Each time I start a new painting, I don't know why I'm there or what it's going to be. It's a feeling that never goes away. Every once in a while a perfect image will pop out and I think, 'That's it, I'm home free.' And then it's a terrific struggle all over again."–B.A.B.

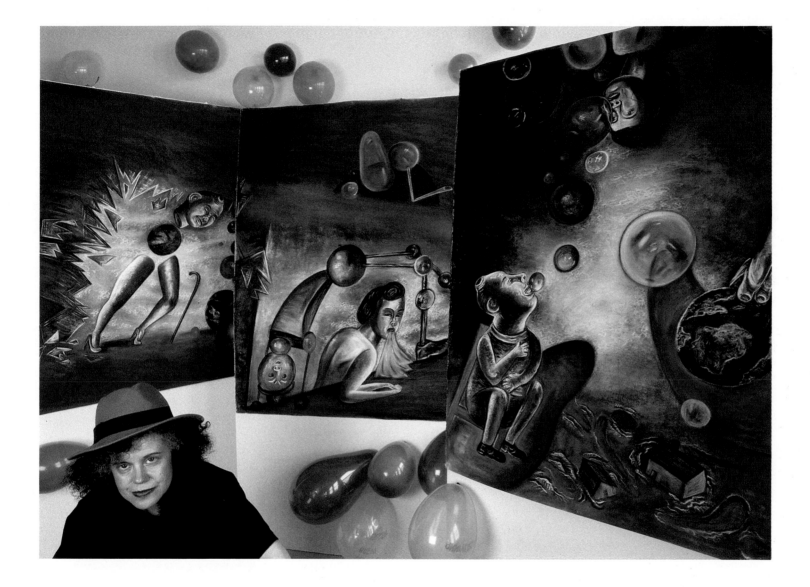

Most of Ellen Berman's paintings are portraits of her daughter Sarah, who is mentally retarded, mute and physically handicapped. Yet Berman paints her daughter in moments of grace, finding beauty in her bulky teenage form, revealing how Sarah communicates without sounds or words. Her paintings depict Sarah in the shimmering turquoise of swimming pools, where the water buoys up her usually cumbersome torso and limbs, or on the infinite stretches of beach, where Sarah reaches through rippling waves to investigate shells, crabs, seaweed. Berman portrays Sarah seated on her own nude lap, in a pose echoing images of the Pieta in which the Virgin Mary holds the dead body of her Son.

Part of the beauty of Berman's work is in her technique. She derives her images from photographs and paints crystalline, realistic details of flesh, hair, fabric and water in photorealistic technique. The beauty of her images also comes from the love with which Berman depicts her daughter. It is a love that has challenged all maternal expectations and suffuses Berman's work with radiant intensity. In one painting, Sarah holds the dictionary that she carried around for months, almost like a talisman—a dictionary she never will be able to read. In another painting, she writes in water with a claw-like bent finger, carving silent signs in the liquid. "Painting Sarah's figure has developed as the sign I can use to talk about emotion and my relationship to the world," says Berman. However, Berman has not always been so comfortable with her feelings about her daughter, and she certainly has not always been aware of how painting could help her explore and express those feelings.

Born in Paris, Texas, Berman grew up in small towns in the rural southeast and central portion of the state. Her early art experience often had to do with giving up, rather than getting. Her first art teacher painted over any "errors" she saw in Berman's work. When she won a city-wide art contest in Bryan, Texas, her father suggested that the prize, an airplane ride, might not be safe, so Berman turned it down. Although Berman loved her art classes, she gave them up in high school to avoid competition with her best friend who was also very interested in art. Berman graduated from the University of Texas at Austin with a degree in Spanish and English, married, moved several times, then settled in Houston, where Sarah was born in 1973. She began graduate school that same year, received a master's degree in English and began teaching at the University of Houston. Throughout the 1970s, she says she had "this low-lying desire to learn to watercolor." Finally, in 1981, she enrolled in the Glassell School of Houston's Museum of Fine Arts. Taking the prerequisite "Drawing Fundamentals" class, taught by Dick Wray, was an epiphany-like experience for Berman. "It was like a message from God—that this was what I was meant to do. Wray was an extraordinary teacher, I had so much positive feedback from him. I suppose I could have had another teacher and never taken a second class." Berman studied there for four years, then quit school to work full-time in her studio.

Berman's first painting, independent from class assignments, was a 1984 portrait of herself with Sarah on the beach at the Gulf of Mexico. "One of the things I wanted to start working out was the effect that Sarah has on me and the effect I have on her, which is very intense," explains Berman. "From the time she was 18 months old, my life changed radically. Not just because it's different to live day-to-day with someone who's handicapped, but because it's changed my sensibilities in every way. It's changed my perceptions about how people get along in the world, how they look at each other, treat each other—especially how people view other people. It's hard to explain with words, but that first painting attempted to begin to convey what we do to each other. I also wanted to convey this sense of defensiveness that I felt. In that first painting, our heads are close together and we're both staring out. My stare is quite challenging."

That same year, Berman painted a second double portrait which she titled "Granny's Chair." She positioned herself and her daughter in front of Sarah's grandmother's brocade rocker. The grandmother, whose presence is implied by the chair, had just died. Sarah's grandmother had never been very accepting of Sarah, and Berman tried to work through her sorrow and anger about that lack of acceptance in the immense, light-filled canvas. For the past few years, Berman has left herself out of the paintings, no longer wanting to challenge the viewer. "I don't want the work to be so confronting," she explains. Instead, the work focuses on Sarah, whose images recall those of great female archetypes. In "Rainmaking," Sarah sits in the shallow water of the Gulf shore with a dark wave thundering behind her. She becomes a priestess, churning up song and ritual to bring on the life-giving waters. In "Red Hibiscus," Sarah dances through the surreal water of a night-lit pool to grasp a tropical blossom. She becomes a fertility goddess whose very touch causes the earth to flower. In "Freefloating," she tumbles through another night pool like a fetus in warm amniotic liquid, all redolent of new life, new possibilities, new dawns. –B.A.B.

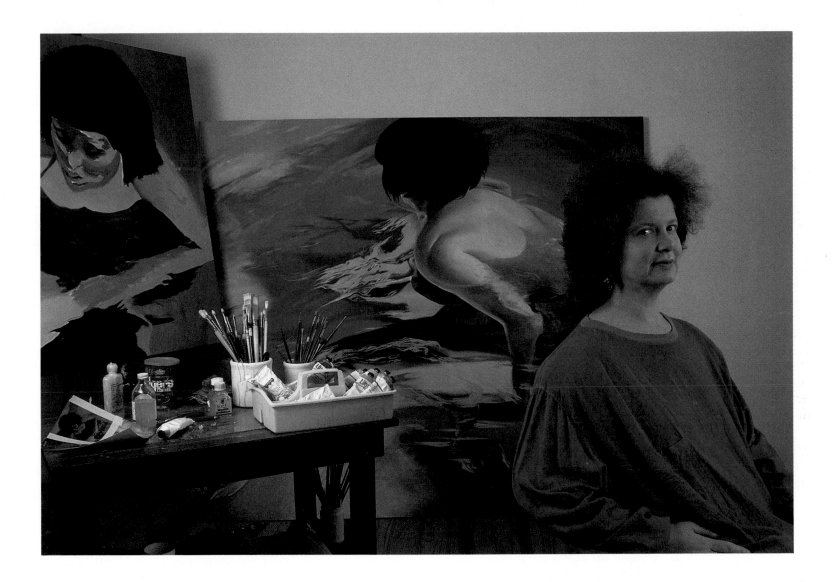

Artists always have sought to change space in order to create new experience for the viewer. But it has not been until the late 20th century that artists have given a specific name to this endeavor. "Installation" refers to the art of spatial reconfiguration. Kim Yasuda is an installation artist who takes a designated site and transforms the space into a sculptural environment for viewers to walk around and through. She uses photography, paint, everyday objects, text and animate objects, arranging them in such a way as to encourage the viewer to consider their evocative interrelationships.

Much of Yasuda's work is autobiographical. "I continually attempt to formulate a balance between the personal and the universal in such a way that the participants have access to their own meaning of my work," notes Yasuda. Her search for self is predicated by issues of ethnic and cultural identity. Of mixed Japanese and European descent, Yasuda was adopted as an infant by Japanese parents living in Oakland, California. "I am, in part, third generation Asian-American lacking a clear sense of my origins," explains Yasuda. "Much of my identity has been based in myth and taken from photographs, especially those of my adopted father, who actively documented the Japanese American community before and after World War II." Yasuda's father, the son of a hotel owner, grew up in San Francisco in the 1920s and 1930s. He took hundreds of photographs but never printed most of the negatives. Decades later, the young Yasuda found and catalogued the negatives, and began to establish a relationship with them by fabricating fictions based on the unidentified images. "It was my way of filling in the blanks," explains Yasuda, "my way of establishing a personal origin."

In the mid 1980s, Yasuda began to explore her personal heritage in a series of photographic diptychs. She juxtaposed images taken from her father's negatives with photographs she took of herself in what she calls acts of "pseudo-rituals." In one example, a photograph of the traditional Japanese tea ceremony is paired with an image of Yasuda's robed back facing away from the tea table in ignorance of the traditions of her own ethnicity. The series deals with what she calls a form of collective "aphasia" (the loss of the ability to articulate ideas), which can result when another culture, such as the Japanese, assimilates into the American mainstream.

Yasuda received her master of fine arts degree from the University of Southern California in 1988. Her master's exhibition was an installation that centered around a wall-sized blow-up of the suburban home of her childhood. A live hedge, bisecting the space, alluded to the civilized act of fencing in and fencing out, and what she considers the absurd separation of private property with camouflaged property. The hedge was pierced with an oval opening through which one could see a condensed mural of the Japanese flag. The central solar disc of the flag had been compressed to the cameo shape that often frames old-fashioned family portraits. On the opposite side of the hedge a diving board topped by a rusted chair cantilevered above an elliptical "pool" of wooden letters reading, "Gravity Was My Enemy." The gallery skylights were replaced with water-filled containers that filled the room with water reflections. The sound of Yasuda swimming laps in a pool filled the space.

Describing her master's exhibition, Yasuda explains, "The installation was set in autobiography, yet I wanted the potential for interpretation to emanate from the viewer's own experience. The diving board, chair and pool with wooden letters, for example, universally relate to all of us as we confront any choice or situation of risk. Many times we remain suspended in our indecision." From an autobiographical viewpoint, Yasuda notes, "Gravity also refers to a childhood experience in which I had to wear a back brace to correct a curvature of the spine. My doctor told me that gravity was my enemy and water was the only means of refuge. For me, water was and still is a form of freedom."

In a 1988 piece called "Abode of Vacancy," installed at the Institute of Contemporary Art in San Jose, California, Yasuda juxtaposed Western and Eastern views of nature. She paired an enlarged photograph of the Yellowstone National Park forest fires taken from a newspaper with a live Monterey pine tree, traditionally used as a Christmas tree. The tree was suspended upside down over a hearth-like sandpit referring to the center of a traditional Japanese interior. "The tea house, as well as all Japanese architecture, has a strong affiliation with nature, " explains Yasuda. "The indoors and outdoors are perceived as being in unity. The Eastern sensibility holds that there isn't space to own, so it is used sparingly. In the West, space is contained; we look out at a landscape through the framed windows of an enclosure and displace nature inside to embellish our artificial structures. I wanted to create a unity as well as a disunity of the two cultures that moved away from the instructive and into the experiential."–B.A.B.

"Feminism and being Black have always been places where I'm really uncomfortable," states Kaylynn Sullivan. "I don't want to be defined by them. All my life I have desperately tried to find some place else to go. Healing gives me my place, whether it takes the form of teaching, laying on of hands or performing."

Sullivan grew up in Des Moines, Iowa, where, she recalls, "there was violence happening all the time in the ghetto and it didn't even get in the news." But violence so savage that it did get in the news happened in Sullivan's own home. "When I was six years old, my stepfather murdered my mother and then killed himself. Because I was also an incest victim of my stepfather at a very early age, I felt that I was responsible for their violence. I thought, 'There's something wrong with me.'" Finding her own place, that place in the mind where she could define and become herself, saved Sullivan's psychic life and was also the beginning of her art. She broke through to the universe of the imagination: "At the time my mother and stepfather died, I wasn't unhappy. I felt I could turn the dial and communicate with my mother." Sullivan's first performance piece, "Victims" (1980), a multi-media re-creation of the murders in her family using journalistic documentation and actual dialogue, was her attempt to unravel these early traumas. "I did 'Victims' because I didn't want to be a victim anymore," explains Sullivan. "I had to work out what happened to my parents and who really lived inside me."

After attending a boarding school during her formative years, Sullivan spent the years between 1968 and 1976 in France, Germany and England. She trained as a dancer and served as a dramaturge for a ballet company. She explains, "I became a dancer because my husband was a choreographer. I could be the perfect reflection in somebody else's eyes, but I wasn't speaking in my own voice." Then Sullivan's body intervened. "I had to stop dancing because of my chronic asthma and a series of accidents—I broke my leg! I had to slow down and ask why I was doing what I was doing, which was being an instrument for a lot of other people." This was a turning point for Sullivan in defining herself on her own terms.

Today, Sullivan makes frequent trips to her land in the New York countryside where she is building a home. She is drawn to the land because, she says, "I receive messages from plants and spirits." Sullivan has translated some of this wisdom from the earth and spirits into the form of tales and performance dialogues. The creation of land as a representative environment for personal identity, and a bridge between people and feeling, is a principle of Sullivan's art. In some of her performance pieces she makes physical environments that approximate the outdoors. For her performance piece "Fandango" (1986), she fashioned a potent landscape of penetrating tones of mustard and violet, with air smelling of mesquite and cedar. Two women stood on a sandy riverbank and snapped and fluttered hand-held fans, amidst congenial conversation. For "Fandango," Sullivan used "fan code"—a secret visual language she discovered and then researched, that had been developed by women more than a century ago as a nonverbal form of communication. In another performance piece, ". . . and he had six sisters" (1984-86), Sullivan collected wives tales from the Carolinas, Florida, Texas, Louisiana, Iowa, Harlem and the Bronx. She first staged ". . . and he had six sisters" at the Public Baths of the City of New York. In a later version of the piece on an indoor stage, the performers stood together on a set that evoked a primordial Louisiana swamp. There on the stage the original external isolation shifted inward: The shelter and comfort of the asylum among women that Sullivan created could also become a prison. The six sisters whispered in pairs and told their tales in dramatic voices, calling and answering one another. They sung, advised, snarled and wept with rising intensity, which threatened to explode into insane rage. Sullivan dedicated this performance to Zora Neale Hurston, an anthropologist and writer whose original research and writing about Black folklore was an inspiration.

Sullivan remains an instrument for others, but now, deliberately. She can make a magical place wherever she is. She can even find abundant nature on the roof of her tenement in Harlem. Sullivan also has celebrated with whole communities in public streets and parks. The personal stories, meditations, found relics, sacred stones, cultural artifacts and culled folk wisdom that she weaves into her rituals also can be found in her live art performances, videotapes and collaged visual objects. Sullivan's rituals are not only therapeutic for those who gather to participate, but each is an expression of Sullivan as an artist. –A.R.

Works spanning 30 years fill Nancy Grossman's loft on New York City's Lower East Side. Abstract and figurative paintings, sculptures, drawings, collages and prints line the sprawling studio spaces. In her drawing room, figures that are rendered, brushed and collaged share the walls and tables with some of the thousands of photographs Grossman collects. "I use these photographs," she explains, "to *see* the figure, its compositions and gestures." Grossman adds, "My artworks sometimes take literally years to execute, thus many are in various stages of completion." Among them are several carved wooden sculpture heads that Grossman is making in an adjoining studio.

From all of Grossman's artistic endeavors over the years, these sculpture heads have drawn the most attention. A 1969 home movie by Adger Cowans shows Grossman in her large woodshop making these sculptures. She is a small woman (then in her 20s) working like a blacksmith or a shoemaker with visible intensity—hammering nails through leather into wood, pouring liquid rubber into molds, rubbing paint into the soft black surfaces. "In the very long process of making a head sculpture, my work begins to change and embody a kind of spirit," notes Grossman. "Sculptures come to resemble people and people are attracted to this resemblance. They catch the spirit and make a connection."

Born in New York City, Grossman grew up in Oneonta, New York, on a dairy farm. Residing in a 130-year-old farmhouse with an extended family of eight adults and 16 children, she remembers farm life as "a launching pad which was a cacaphony of humans and animals, wildness and woods." Her Jewish education—"I studied Hebrew, the Torah and Talmud with my religious father"—was another source for Grossman's mystical-mammal consciousness. This rich, stimulating "soup" may account for her keen instincts about, and intimacy with, animals and natural forces.

Male and female figures have been equally fascinating to Grossman. "I'm interested in the figure as a formal element and as the life force to evoke a primary feeling, whether it's comfortable or not," she says. However, Grossman's work is not *about* women or men. Her figures are meant, rather, to evoke fundamental questions of human existence and expression—self and other, human limitation and potential, evolution. In her work, men and women are victims and survivors of personal and cultural aggression and repression, both internal and imposed. Early in her career, Grossman painted reclining figures "that stretched themselves along the landscape and merged with it. I painted male and female figures enwombed in fetal positions or stopped in earthbound flight—inhabitants of the subterrain." During the same period, she fashioned women who were embattled and angry, defending themselves from attack. She explains, "The women were no longer buried in the earth but standing in the open, being fired upon—anchored to one spot and ducking bullets zinging by or being worried to death by birds who thrashed and beat the air with their wings." She adds, "Now I know that they were me, my mother and my perception of women in the world that I experienced."

A Guggenheim fellowship in 1965 provided an exhilarating and productive period of work for Grossman, and a large number of pieces were exhibited that same year in two highly acclaimed, one-person exhibitions. The following year, Grossman recalls, "I decided to give *myself* a fellowship." For nine months Grossman illustrated children's books exclusively to earn enough money to enjoy a sustained time in her studio. "After nine months of sitting and working at a drawing board doing book illustrations, my energy had become quiet, contained, distanced, suppressed," explains Grossman. "When I returned to my artwork, I began to draw human heads with this same muzzled feeling about them. To make the sense of restrained emotion and energy more palpable, I began to make sculpture."

In 1969 Grossman exhibited the first of her sculpture heads and quickly became both renowned and suspect for these black leather "personae" that felt uncannily lifelike. Their intensely focused features seemed to stare the viewer down. "Attractive, powerful and scary, they were loved and feared at the same time," observes Grossman. Some people who bought the sculptures saw them as benign protectors, like totem animals or witches' familiars—animal and spirit companions. For Grossman, as well, these personae can contain personal and social dichotomies, and can thus stand counterpoint—on "the other side of 'the other'"—from cultural estrangement. –A.R.

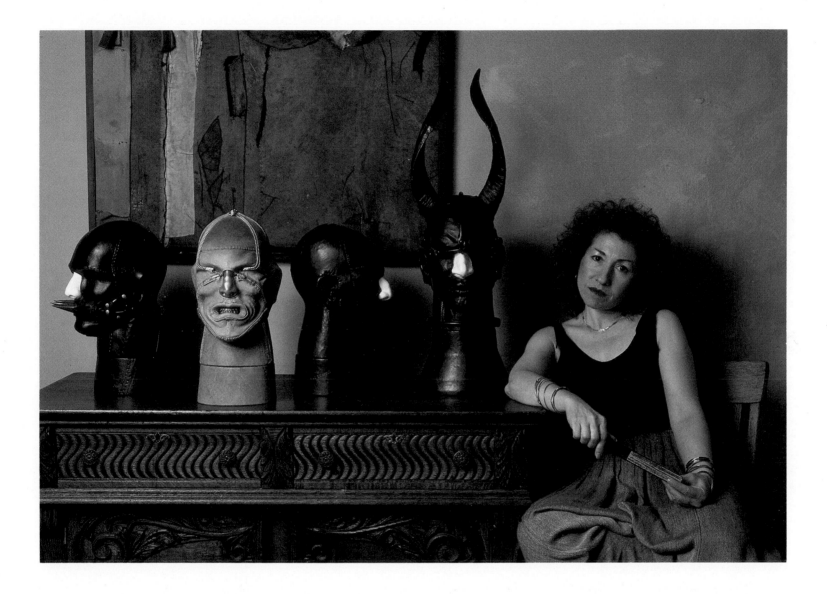

"Why do I do art? To keep me sane," asserts Gretchen Lanes. "It has to do with feelings about my family, the way I was raised. I have a lot of apprehensions, a lot of ghosts lying around inside me. In my paintings I get that stuff out and I think I actually start to poke fun at it. Another reason I have to paint is that it gives me structure in my life. I'm very conscientious about doing constructive things and this feels constructive to me. Painting is meditative and centers me."

Raised on a farm in Chelsea, Massachusetts, Lanes says she drew horses and painted people "just to see if I could. But to be an artist was not something I even knew about," she admits. "It just never occurred to me." When her family left the farm and Lanes "got into civilization," she became quite concerned with things like cheerleading and "making social points." Indeed, her initial involvement with the art world was primarily social. Lanes wanted to become an "art star" like some of the people whom she met in college but, she admits, "It wasn't until I quit wanting to 'be an artist' that I really became one."

In college, Lanes met and married artist Jerry Kearns. They moved to Rome and later to the West Coast where he was offered a teaching post. "He was very influential on me," notes Lanes. "I really liked exploring with my eyes and he helped me explore my visual environment. He was like my mentor." However, when Kearns decided to return to the East Coast, Lanes elected to remain in Los Angeles, so the marriage ended.

In the early 1970s, Lanes was working on large, hard-edge abstract paintings. "At that time, I didn't have any self-confidence," recalls Lanes. "I made a couple of attempts to be like a 'real artist' but I knew my work wasn't strong enough, so I decided to quit." However, she didn't quit altogether. In the midst of her cool abstractions, Lanes had made one small figurative painting that had an uncanny surreal presence. Since it didn't resemble the paintings being highlighted in art magazines, she didn't think it "counted." Lanes didn't consider this painting the work of a "real artist" and didn't intend to exhibit it. As time passed, she found herself doing more of the intense miniatures, though she continued having trouble identifying them as valid art.

In 1976, Lanes was in a serious automobile accident. Her pelvis shattered, she was forced to spend months in convalescence at her mother's home. When Lanes returned to Los Angeles, she felt lost. "I didn't know who I was. I didn't have a job. I had only one friend." So she pulled out her oil paints and began a series of self-portraits. Like the Mexican painter Frida Kahlo, who had been similarly bed-bound by an automobile crash, Lanes began to search the landscape of her psychology in the ever-changing terrain of her face. She painted not only the visage she saw reflected in her mirror, but also what she felt lay beneath the surface.

In the late 1970s, painter Lynn Foulkes curated an exhibition entitled "Imagination," and included several of Lanes' works. Lanes' work immediately attracted the attention of major commercial galleries and she has exhibited regularly since. But Lanes hates to let go of her art, and she remains ambivalent about her relationship to the commercial gallery world as a means for selling her work. "In today's gallery system, are they selling a work of art because it's good or because of the surface it's covering?" asks Lanes. "In my opinion, they're selling surface, not quality."

Lanes' reluctance to release her work may have to do with the fact that her paintings are intimately personal. Lanes supports herself as a hair stylist and her self-portraits often have shaved heads. Hair acts as a potent symbol in many of her paintings. In a double portrait called "Sam and Delilah" (1984), she sits at a dinner table with her balding lover. A bowl of spaghetti in front of him alludes to Samson's shorn locks; Lanes holds up two fingers like scissors. Behind her is a barber's pole, behind him a twisted Solomonic column. Lanes' use of the Samson story relates directly to her personal experiences: She speaks of boyfriends who have been threatened if she tried to cut their hair, of customers who have commented on the power she has over them as they sit in her salon chair. "Sam and Delilah" also has archetypal significance: It calls into question the power relationships between the sexes, the challenge that women's power has to men. –B.A.B.

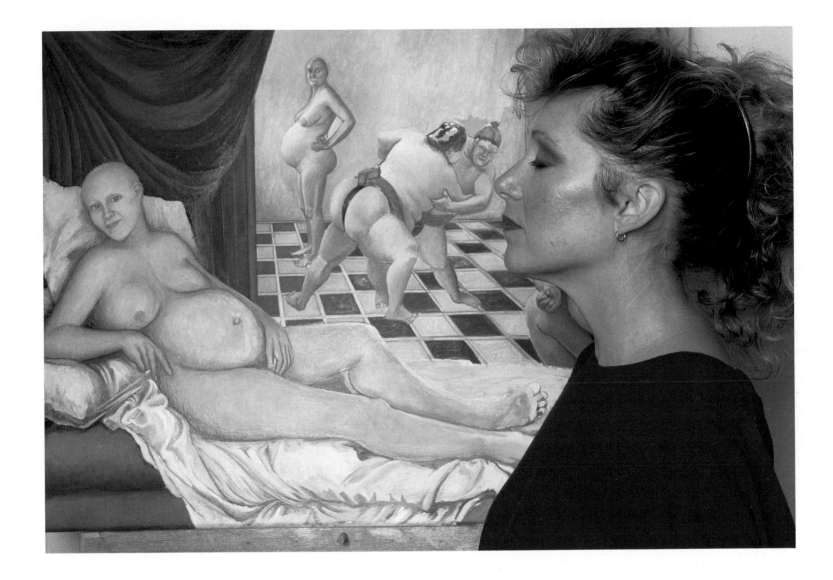

Houston, Texas, is poised between the blaring carnival of Mexico and the dank, moss-hung recesses of the Deep South. The city's pristine skyscrapers of angular silver and grayed cement tower over barrios and bayous, over new stucco houses of brash pink or turquoise, over old plantations and slave quarters shadowed by heavy trees. Joanne Brigham's art reflects these two sides of Houston.

Exploring interior spaces has been an ongoing theme in Brigham's art. Born in Allentown, Pennsylvania, she was described as "the artist in the family." Brigham says she spent much of her childhood trying to build her own private spaces—little villages made out of wood scraps, twigs, paper, and paint. While studying for a master's degree in art at Southern Methodist University (SMU), Brigham returned to the kind of art she had loved as a child. She began building little sculptures of houses that opened to reveal painted insides. Gradually, the painted interiors became more important than the superstructures and Brigham discontinued sculpture and worked solely on the images of interiors.

Brigham's years at SMU during the late 1970s were not easy. "It was a bad time in the art department. The administration had decided to build up the business school and cut way back on the arts. They cut the studio faculty down so much that all that was left were older, tenured men. I was doing these things that nobody understood, painting these images and writing captions below them. They were full of love, really female things, but my teachers told me they were like Hallmark cards." Brigham had to figure out a way to produce art that was genuinely hers and that would satisfy the expectations of her male teachers. She abandoned figurative representation in favor of more architecturally based sculpture, and finally received her degree. Brigham credits the rising feminism in the arts with giving her the strength to persevere. "Reading Judy Chicago's book, 'Through the Flower,' got me through graduate school," notes Brigham.

When Brigham moved to Houston, the small domestic sculptures were transformed into skyscrapers, although she still created interiors. Sections of the tall buildings opened to reveal intimate rooms and hallways within. While working full-time at a Houston hospital, Brigham found a warehouse and gathered a group of women artists to rent studio space there. One artist who looked at her work was amazed at how much it resembled the work of the Mexican surrealist painter Frida Kahlo. Intrigued, Brigham rushed to find reproductions of Kahlo's paintings and was profoundly pleased by the uncanny commonality. She has since traveled to Mexico to visit Kahlo's house, and has read everything she could about the famed artist who was also married to muralist Diego Rivera.

If the Mexican surrealist painter Frida Kahlo had illustrated the stories of Southern regionalist writers Flannery O'Connor and William Faulkner, she would no doubt have come up with the same kind of fantastical, introspective imagery that characterizes Brigham's work. While Frida Kahlo focused on her own face, Brigham portrays rather anonymous "Everywoman" figures in her small paintings. Instead of focusing just on the psychological presence, as did Kahlo, Brigham places her figures in evocative environments. They appear either outdoors, amid the mysterious expanses of nature, or in cemeteries that seem to stretch beyond the shadowy horizon, or in large empty rooms that open into other hazy interiors.

Brigham met her husband, fellow artist Jeff De Lude, in Houston. They were determined to find a business that would support both of them, but also allow them the time to continue doing their art. In 1985, they founded Mannerisms, Inc., a company that focuses on decorating the interiors of houses and restaurants. They paint walls to resemble everything from aged and cracking Roman frescoes to Early American brick fireplaces. The Brigham-DeLude home is a showcase for the Mannerisms visual repertory and seems a logical—if unusual—extension of the two painters' art. Brigham's decorating business has taken her to New Orleans, where she has reconnected with the Southern Gothic romance of her youth. Although born in Pennsylvania, she spent long periods in her mother's native South Carolina. The New Orleans cemeteries reminded her of those she had seen as a youth, and of stories she remembered hearing about a ghost named Alice. Today, Alice has been reincarnated by Brigham in a painting by the same name. A phosphorescent tear-shaped cloud, she emerges from a simple stone grave marker and soars towards the dark silhouette of a tree.

Brigham's life has always been intimately interwoven with her art. She and DeLude recently purchased a home in Houston, located next to a cemetery. Their property includes several dilapidated wooden shacks. She no longer paints in the warehouse, but in one of the ramshackle sheds. Brigham says she has found her private space, her own little village, where she can explore both physical and psychological interiors in the city that merges the Deep South of her mother and grandmother and the Mexico of her spiritual grandmother, Frida Kahlo. –B.A.B.

Jaune Quick-To-See Smith leans canvases against the walls of her studio, a large adobe building with its broad door open to the enclosed courtyard of her New Mexico home. She smears the fabric surfaces with thick impastos of pigment, building up colorful patchworks, which remind her of the land as seen from the sky above or from airplane windows. A rooster crows outside. A guinea bird waddles by, chased by a large gray goose. Flies circle the puddles of paint. The searing heat ripples in. Cheyenne, a large palomino horse, persistently rattles a chain-bound door jam indicating hunger. Smith, laughing as she takes him a handful of carrots, quips, "It's like Pavlov and his dog; I'm the dog!"

As soon as the paint begins to dry on her ring of canvases, Smith starts scraping it off. She paints, scrapes, paints, scrapes, then paints again. "If the image comes up too fast, or too easy, I'm not satisfied," explains Smith. "I have to work at it." Smith's patchwork forms are derived from a bird's eye view of the arroyos, creeks, mesas, valleys of the American Southwest. Finally content with her shifting planes of aerial landscape, Smith paints a layer of pictographs over each canvas. The pictographic layer comes from her Native American heritage—from the figures carved on the rock walls of the West, from the geometric vocabulary of Plateau Indian beadwork or of the Navajo blankets on her father's horses. On one, a herd of horses race through lightning-etched canyons. On another, four horses rise to mystical union with the moon. Other pictographs are more abstract: stepped pyramidal forms, crosses, T's, discs, spheres, spirals. Each clutch of pictographic forms is autobiographical. Each combination of landscape and text relates to her knowledge of the world. But her compositions are ever altered, modified, reworked through her artistic process: her patches of color hover, float and slide when she repeatedly paints then scrapes them. Her pictographic vocabulary continues to change as well, always evolving to reflect new experiences and observations.

Even Smith's process recalls her Native American heritage. Suspending the painted surface, treating, staining and scraping it—all these acts relate to the ancient arts of hide preparation. Her lifestyle is reminiscent of Native American ways as well, as she opens her work space to the sun, incorporates animals into her home, travels constantly to gather with other Native Americans and share through words and visions and traded images those essential qualities and experiences of her people. Smith is of Flathead Salish, French Cree, and Shoshone descent. She was born on the confederated Salish and Kootena reservation in Montana, at the Jesuit Mission. "The Jesuits enslaved the young Indians, forced them into church and put them to work on cattle ranches or in the orchards," explains the artist. "We were forbidden to drum, sing, dance, speak our language, carry anything of our culture . . . but even with all that people would gather in a cabin, cover the windows, and drum and sing." Smith talks of the destitute situation of tribal peoples in the 1930s and 1940s, a time when the old ways of living were taken away, a time of hunger and uncertainty. Until a few years ago, Smith did not know her mother. She grew up with her father (Smith was his name), a trader and trainer of horses, and traveled with him as he pursued his often precarious trade. She remembers living in more than 50 places before she finished high school.

In high school, Smith realized that art, which had given her the most pleasure throughout her life, could also be her profession. She took some of the money she had earned while working as a field hand and enrolled in a correspondence course called "Famous Artists." Then she saved more money and began junior college. "Washington state has a wonderful system. The tuition was only $50," she notes. "That was a real blessing in my life because I had this driving need to go to college, this terrible need to be equal." She started college in 1958 and was the only woman in her painting and drawing classes. She remembers with anguish when her teacher, a commercial artist, called her to his office and informed her: "You can draw better than any of the men here but you'll never be able to make it except as a teacher, because women can't be painters." She remembers sitting in his office with tears pouring down her cheeks, then determining to get that teaching degree so she could continue with art.

But it wasn't easy. Several times, Smith had to leave school to work and support herself. It wasn't until 1976 that she received her bachelor of arts degree in art education at Framingham State College in Massachusetts, but she never stopped painting. Just as she entered the University of New Mexico (UNM) for graduate work, her paintings began to sell. At last, contrary to her professor's prediction, Smith was a professional artist and did not have to pursue teaching to "make it." However, since then, education has remained a major commitment for Smith, who gives numerous public lectures on contemporary Indian art and the contributions Native Americans have made to our culture.

Change, growth, insight must be part of the work to give Smith artistic satisfaction. "I don't just come here to create a product. I do a lot of experimenting. That's how you find yourself. This is a search, an adventure. I'm going on a journey each time I begin a canvas."–*B.A.B.*

A major historical precedent for Madden Harkness' large multi-media drawings is the graphic work of Spaniard Francisco de Goya, with its skillful draftsmanship and powerful evocation of the dark side of the psyche. Yet, while many of Goya's images were responses to social ills, Harkness explores a nightmare realm that is intensely introspective and personal. Rather than cower before the shadowy incubuses that populate her visions of fear, she seduces them, embraces them in a swirling, hallucinatory dance of darkness.

Harkness' "Baptism," for example, portrays a Michelangelo-like titan doubled over, upside down, as he might be seen by a baptizer about to submerge him in water. In spite of his tense, muscular presence, the giant seems helpless, swept over by primal forces. His mouth opens in a silent scream. His black beard obscures his neck and suggests the decapitation of John the Baptist. It looks as if he has been torn apart by fright.

The style and substance of Harkness' art, as well as its impassioned psychological tenor, can be traced to her first trip to Europe. It was then, at age 15, that she was consumed by art and compelled to find her place in art history. "The art in Europe overwhelmed me; it disrupted my inner chords, my relationship with life," recalls Harkness. "I so desperately wanted to do that kind of art, to be a part of it." Harkness has loved drawing since grammar school and remembers telling her sixth grade teacher that she wanted to be an artist. It wasn't until her parents insisted on the European tour that she found herself obsessed by art. "I remember that I didn't want to go to Europe," admits Harkness. "I was 15 years old and wanted to go to the shore for the summer, have a boyfriend, eat hot dogs. I thought the whole world was probably just like where we lived, so why travel? Europe changed my life, especially Italy. I cried almost every time we left a town. I remember specific pieces of art that I saw—Bernini's David and Michelangelo's unfinished sculptures."

Harkness was fortunate to return from Europe to an exceptional high school and an inspiring art teacher. "There were only two art classes, but they were wonderful," notes Harkness. "I owe a real debt to my art teacher Mrs. Peterkin. I still keep in touch with her. The courses I took in college afterward didn't compare to what she taught and how she taught it. She really encouraged me, which was one of the first times I felt personal encouragement."

Harkness studied art at both Tufts University and the Boston Museum of Fine Arts School. While in Boston, she experienced a major personal trauma that became connected, in her mind, with art. For years afterward, she couldn't go into art museums or galleries. "It felt very painful but I couldn't identify why. I just knew I was angry and hurt, so I kept trying to push that part of myself away. I would start these little careers, then get to a certain point and think, 'This isn't what I want to do.' Then, right around the time I was getting married in 1979, I thought I had to make a decision about what I was going to do . . . so I really looked at it and realized that what I most wanted to do was draw and paint. It was scary and risky, because I didn't want to fail." Harkness has not failed: Her first commercial gallery exhibition in Los Angeles in 1988 sold out on opening night!

Harkness works on the matte side of huge sheets of transparent drafting film. She begins with fairly traditional academic drawings, then transforms the figures with an alchemical combination of gestural erasures, broad turpentine washes and active, almost athletic strokes of iridescent paint. Harkness employs images taken directly from past art, especially the Italian Renaissance art that so impressed her as a youth. Her recent painting, "The Messenger," includes a head taken from a drawing by the Italian Renaissance master Andrea del Sarto. "For a long time, I repressed my feelings about the Renaissance, about how much I love that style, how much I love its romantic and heroic and spiritual elements," explains Harkness. "Especially during my art education, it never seemed safe to bring that out. I felt it was part of myself that I shouldn't reveal, that if I was going to be taken seriously, I had to work in a way that was 'tough.' It wasn't until I started working with the figure again that I began to understand the romantic Renaissance components in art. When I was able to put them into my work, it all became an acknowledgment, a direct way of connecting with my past. It was also a kind of healing."

Because of the vitality of her line and the shimmer of her lead and polyester surfaces, Harkness' works are not excessively negative. She pulls the viewer into a shadowy world of moonlit visions, but avoids the shallow despair of so much contemporary art. Harkness would agree with Goya that the monsters are there, and that in accepting and living with them we begin to know ourselves and our dreams even better. *–B.A.B.*

Bibiana M. Suarez calls herself a woman without a country. She was born and raised in Mayaguez, Puerto Rico, but has spent her adult life in Chicago. "I could go back to Puerto Rico, but I've been in the United States for nine years now and I've really changed," states Suarez. "There's still a provincial mentality in Puerto Rico. It's a small place and the culture is very traditional, but in Chicago—there are parts of this culture that I can't deal with—I feel I belong, but I don't. I also feel I belong in Puerto Rico, but I don't." As a result of this confusion, her artwork reflects both her search for an identity that is authentically her own, and her existence on the edge between two cultural traditions.

Suarez creates immense drawings in which space is warped, bent, distorted. Fantastic figures spin out of control, mechanical forms gyrate madly toward the viewer. Disjointed arms, legs and torsos are caught in the tense, distended membrane of the drawing surface. A carousel pauses on its unending round, displaying a claustrophobic populace of clowns, queens, and dunces. A vase, framed by dozens of wildly flutter-ing wings, attempts to lift into flight but is grounded by its own hysterical effort. Suarez's world is animated by the surreal absurdity of carnival.

The Latin American confluence of Catholicism and spiritualism forms the foundation of much of Suarez's art. She comes from what she describes as a "very comfortable middle-class family." Her family was devoutly Catholic, but her grandmother was a spiritualist, and Suarez remembers seances in her childhood home. Suarez's art relates to the cult of devo-tion, which is important in Hispanic culture—to the "retablos" (religious paintings), the presentations of "ofrendas" (offerings), visions, "santeria" (the cult of the saints), and "espiritismo" (spiritualism/witchcraft). Hav-ing been raised among these diverse influences, Suarez now draws upon them for inspiration. "The faithful find spiritual release through religion; I find it in my art," states Suarez. "That's why I include ritualistic elements in my work, why I use masks, chalices, temples."

Suarez's work is mystical, yet it is also political. She has done several drawings that relate to the Puerto Rican play "La Carreta." "Carretas" are the wooden carts pulled by bulls, which were an ubiquitous element of rural Puerto Rico. The title also refers to being yoked to an eternal burden. The play traces a group of Puerto Ricans who, in the 1940s, move from the countryside to San Juan in search of a better life, and then on to New York City, still in a frustrated search. They are confronted by the problems of modernity and industrialization: drugs, alcoholism and changing morals. They are also plagued by an enduring problem for Puerto Ricans: the lack of national identity, the ambivalence of being

technically part of the United States but in actuality second-class cit-izens. Suarez was particularly taken by one line in "La Carreta." The old patriarch, who never left his land and thus died there alone, said, "Cuando los hombres nos patean, siempre queda la tierra para dejarse querer." ("When men kick us, we still have the land to love.") Inspired by those words, Suarez used her whimsical and extravagant vision to create a compelling but unsettling image of fragmented figures and tilted, frac-tured, bound land.

Suarez began her education in her native Mayaguez, at the local campus of the University of Puerto Rico. Teaching there was Maria Luisa Castillo, one of Puerto Rico's arts pioneers. In 1918, as a very young woman, Castillo had attended Pratt Institute in New York, and decades later, she did graduate work at the Art Institute of Chicago. Castillo became Suarez's counselor and mentor, encouraging Suarez to follow her footsteps to the Art Institute. "I felt Chicago would be a good intermedi-ary point, a good point of departure, a place where Eastern and Western mentalities meet," explains Suarez. "But the first year was a shock. I was terrified of the winter and the first autumn was horribly depressing for me. The lack of light really affects me," observes the artist. "In retro-spect, I think that's why I'm interested in light in my drawings, in chiaroscuro, the high contrast of light and dark. I create an atmosphere of intensely lit space in my drawings to make up for the lack of light in my city."

The Art Institute of Chicago not only has given Suarez an excellent education, it has afforded her the opportunities to do two things that are equally important in her professional development. She has begun teach-ing, which she finds "very rewarding," especially when she works with young Hispanics. "My contribution to that community could be creating a role model. That's a major problem in all minority communities, the lack of positive role models." The Art Institute also has given Suarez the chance to act as a bridge to her native Puerto Rico by returning to her homeland each year and establishing an ongoing exchange program with schools there. As a result of Suarez's efforts, eight Puerto Rican stu-dents received scholarships to the Art Institute in 1988. Suarez considers this work her mission, her commitment to her country.–B.A.B.

Lili Lakich loves to tell the story of her father's return from military service and how profoundly the subsequent family vacations influenced her direction as an artist. "When my father came home from the Korean War, the first thing he did was buy a brand new, light-blue Chrysler," recalls Lakich. "It was 1953 and I was nine years old. We drove all over the United States, visiting relatives and old friends from California to Florida. By day we read all the clever Burma Shave signs and stopped at every souvenir shop or roadside attraction that was made to look like a wigwam, teapot or giant hamburger, but it was driving at night that I loved best. It was then that the darkness would come alive with brightly colored images of cowboys twirling lassos atop rearing palominos, sinuous Indians shooting bows and arrows, or huge trucks in the sky with their wheels of light spinning. These were the neon signs attempting to lure motorists to stop at a particular motel or truck-stop diner. It was always the neon signs that I remembered."

Lakich studied at the Pratt Institute in New York, then moved to San Francisco, before settling in Los Angeles in 1968. "When I was in San Francisco, I never had a single idea, I couldn't think of a thing," admits Lakich. "Then the minute I got to Los Angeles—ideas! So I said, 'Well, this is the place.'" By the late 1970s, Lakich was painfully aware that neon was dying, and that it had been dying as a medium since the late 1950s. It was becoming increasingly difficult for neon artists to get the beautifully colored glass and other materials of the medium. As neon fabrication was being discontinued, the tube benders were also disappearing. Concerned about the future of neon, Lakich founded the Museum of Neon Art (MONA), which opened in May 1982. "Neon is the great American art form," states Lakich. "America's monuments are the neon signs. Places like Times Square and Las Vegas are meccas for the American dream. I just hated to see neon die. I thought the only thing that would turn it around would be to establish a museum dedicated to the exhibition and preservation of this art form. " MONA has collected and preserved several old neon signs like the ones Lakich saw on that formative trip with her father in the 1950s. The museum exhibits both contemporary neon art and its forebears.

In addition, Lakich didn't want her own art to be merely ephemeral, to be made and then discarded. By founding MONA, she has been able to develop and display her work, along with that of several hundred other artists who have exhibited at the museum. MONA has clearly revitalized the medium and created a renaissance of interest in neon. Lakich does both public and corporate commissions, as well as personal pieces. She feels comfortable with the former and, since Lakich considers neon "a street form, very public and very social," she wants to continue making community works.

Lakich's personal work is largely figurative. She begins with drawings, explaining, "I have to know the idea is not frivolous, nothing I'll tire of easily." Then she designs and engineers the construction, and finally builds the sculpture. Her "Love in Vain," constructed in 1977, is a 12-foot monument Lakich describes as "perhaps my greatest personal triumph. I did the drawing in 1969 and thought it had a lot of feeling and meaning, but people I showed it to didn't know what to say about it." She observes, "I think they were somewhat embarrassed to see an image so emotionally raw and bizarre at the same time. A woman as an overstuffed chair? What did it mean? What were those things around her head? Why the vacuum cleaner? Was there some deep, dark, secret meaning that they just weren't getting? There was something about the drawing that was very powerful for me. The utter immobility brought on by the destruction of a love affair. Eight years later the idea still meant a lot to me, and I had the courage to build it into a gargantuan tribute to 'Love in Vain.' "

Lakich's sculpture "Elvis," completed in 1985, was originally conceived as a tribute to Presley and as a formal challenge: She wanted to work with a silhouette to gauge its impact. The metal cutout of Elvis floats before a rainbow halo of light. Serpentine tubes undulate down the performer's truncated legs, others fly off his jacketed shoulder. Yet other neon tubes make angular electrical zigzags over the notorious hips and out the neck of the blaring guitar. This neon sculpture is a powerful and effective icon, as animated as the personality it portrays.

Lakich transforms many of her portraits into emotionally charged archetypes or icons. "I came from a Greek Orthodox family," she explains, "and grew up with mosaics and frescoes and religious icons. I've always been influenced by the power of those Orthodox icons. The materials are very lush, very glittery. They all glow in the dark." Of course neon is the 20th century medium that glows like Orthodox icons. "Neon is associated with the highest aspirations and fantasies of the American dream as well as the lowest expression of commercialism and banality," states Lakich. "There is no other art form that is as symbolic of the American spirit." –B.A.B.

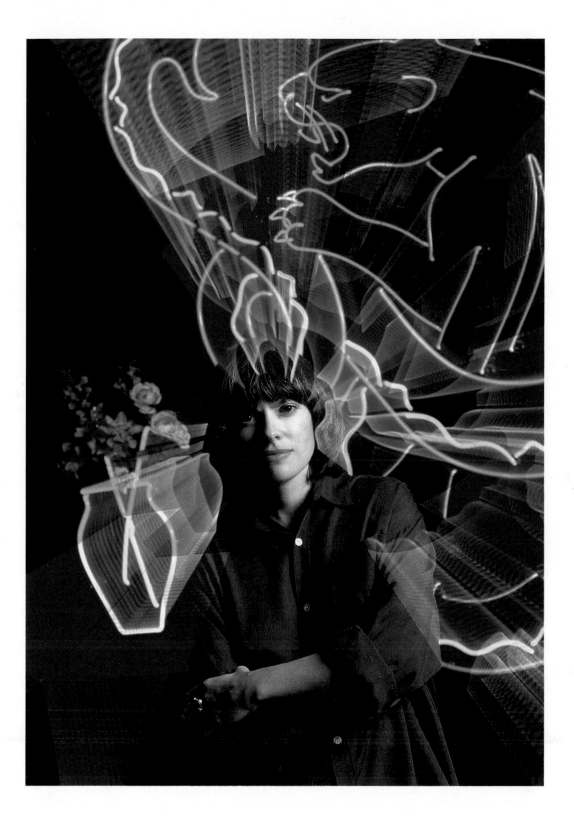

The apparent contradictions of human intelligence fascinate Michiko Itatani. "We are on this seemingly insignificant planet in this insignificant location in the galaxy," observes Itatani. "Being confined to this small dot, the human mind travels around the universe. Even before we could circle the earth, we started to search the inner and outer space of the universe. I am interested in why the human mind works this way and how. I inherited that tradition, and my paintings are proof of my inquiry. The way the human mind works intrigues me, especially in the extreme conditions of being a victim/an offender, an introvert/an extrovert, and so on." She adds, "For me, to be an artist is an intellectual choice and a carefully chosen commitment. There is no intoxication. My painting is a painterly diagram of my cosmology. It's incomplete, fragmented and under inquiry. I have a disproportionate ambition to come to terms with this inquiry. The inquiry has become my way of life."

The place of the human species in the universe is exactly the issue Itatani addresses in her art. She paints large, irregularly shaped canvases on which titanic human figures tumble through kaleidoscopic mosaics of color and pattern. The figures are jumbled, fragmented. They seem swept by inexorable forces, swirling madly through an awesomely powerful cosmos. Painted in black, white and gray, the figures refer to sculpted or photographed forms, rather than to sensuous flesh. Itatani wants the figures to be believable, so she refuses to stylize them, but also wants them neutralized, to avoid specific reference to race, gender or age.

The spatial constructions in which the figures move are multidirectional. Itatani avoids unified perspective views, so that her painting space carries the same potent ambivalence as her figures. Each of her canvases is a fragment, a fractured sliver of a whole. She spreads the fragments over broad wall installations, so that her implied pictorial environment expands far beyond the individual frames. Itatani's use of fragments was inspired by the Pergamum Altar of Ancient Greece. The altar was in complete ruin when excavated by German archaeologists in the 19th century and the museum reconstruction in Berlin is still missing arms, legs and heads. Not one figure is complete yet, Itatani notes, "The incompleteness seems to have stronger impact." Viewers cannot absorb it all in in one passive sweep. They must become actively involved, using their imaginations to recreate the conceptual leaps between the carved marble pieces. Itatani wants to elicit the same engaged response from her audience.

The pacing of Itatani's paintings and the juxtaposition of the grayed figures and the scintillating colors of their cosmos are reminiscent of the carefully placed boulders of Japanese Zen gardens. The fastidiously drafted parallel lines around Itatani's figures resemble the raked sand; the scintillating explosions of swirls and curves recall both the artificial rivers and the delicately dwarfed trees of such formal gardens. Although Itatani acknowledges the essential Japanese character that is one aspect of her art, she was not always comfortable with influences from her native country. "At first, I avoided or dismissed the influence from my cultural background in my work and tried to work with the learned vocabularies of Western culture," explains Itatani. "However, when I began to feel close and connected to my painting, I realized that my work was under the strong influence of Japanese aesthetics and philosophy. I hope I am now using all that I know from East and West to proceed in my inquiry because I believe I am now a product of the two."

The inherent contradiction of choice—the fact that choosing toward one thing always means choosing away from other things—has been a constant theme in Itatani's life and work. Born and raised in Osaka, Japan, she has lived all of her adult life in Chicago, Illinois. Having received her undergraduate degree in philosophy and literature, Itatani intended to accrue experience as a writer, so she came to the United States and did graduate work in painting. But instead of fueling her writing, Itatani's studies seduced her permanently into the visual arts. Itatani is now an instructor in painting and drawing at the Art Institute of Chicago, where she received her master of fine arts degree, however, she also has continued writing. Through her writing, Itatani reveals some of the conceptual bases for her visual art, further exploring the dilemma of choosing. In her image-making, Itatani explains, "It's an issue of representation: You choose one and then other possibilities are eliminated. Gain one and lose another; lose one and gain another. An accumulation is about condensation and focus. I learned that from the aesthetics of Japanese forms such as Noh theater and stone gardens, which present the reality of human existence as symbolic drama in the context of the larger universe."–B.A.B.

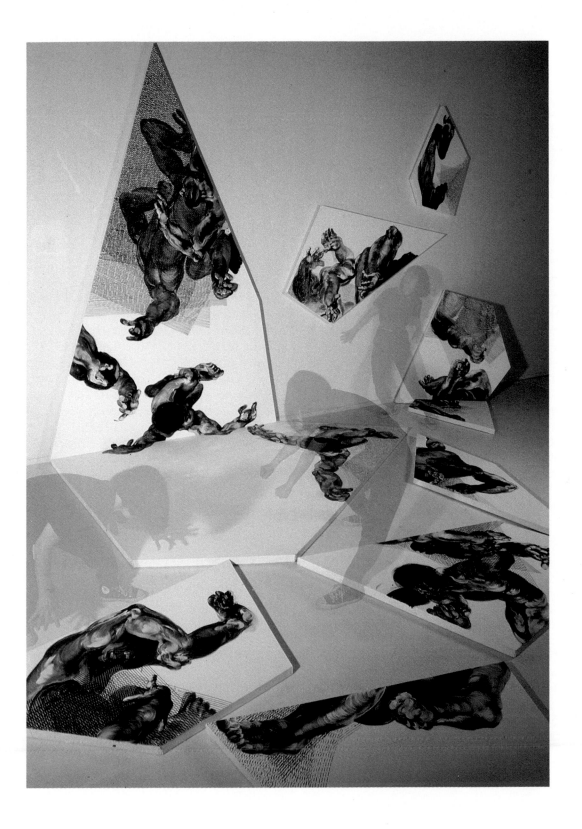

"A woman can make the choice to be an artist and decide to go all the way, but there is still tremendous guilt," admits Miriam Schapiro. "You feel as though you're stealing power." In the early 1950s, Schapiro and her husband, Paul Brach, lived in the heart of the New York artists' district, showing her work at the Stable Gallery. She had her first one-person exhibition of abstract expressionist paintings in 1958 at the prestigious Andre Emmerich Gallery. Schapiro was one of very few women whose paintings could be seen in the best New York milieus during the 1950s and 1960s. "There was an implicit quota system determining how many women could be recognized," recalls Schapiro. "In one sense I was grateful to be a token in the art world, but the pain and anxiety were far greater than the pleasure."

Referring to her childhood, Schapiro said, "Mine is a traditional story. Throughout history, many women who became artists trained in their fathers' studios." Schapiro says her father "had a passion for art that was very deep." He took his daughter to museums, and on long walks he would explain the work of artists like Paul Cézanne, Vincent van Gogh and Paul Gauguin. "Both my father and mother were disciplinarians," recalls Schapiro. "They insisted that I do my drawing. At the end of the week, my father would critique my drawings." In contrast, Schapiro remembers her mother as being "housebound—but when the Depression came my unskilled mother had to get a job and did." Schapiro became a mother herself in 1955 at the age of 32. "If you were to survey celebrated women," she points out, "with every step toward real success there came a baby. You need to have the sense that you're fulfilling your obligation to society. Those of us who were pioneers were motivated to become what society considers a complete woman."

Schapiro overcame fragmentation in her personal and professional life after the birth of her child by approaching her paintings with a renewed mental image of herself. New vertical images emerged on her canvases. Her "Shrine" series of the early 1960s was based on long rectangles rounded at the top and divided into compartments that symbolized parts of the artist—gold for aspiration, a piece of a painting quoted from an artist of the past, an egg for the female creator, a mirror for a look at herself. But not until the women's movement did Schapiro know that her intended audience was female. In 1966 she read Doris Lessing's "The Golden Notebook," an analysis of female socialization, and strongly identified with Lessing's struggles. This private connection with another female artist was to lead to more public commitments a few years later

when Schapiro became a leader in the women's art movement as both an artist and a teacher. "My life changed when I moved from New York to California and began to work publicly as a feminist educator. I began to understand and then to work from women's culture, incorporating techniques and historical artifacts associated with the feminine into my collages. I invented the word 'femmage' (a female version of collage), changed my modus vivendi in art and pioneered a whole new approach. For the first time in my life, I wasn't receiving all that rejection and misery. Instead, I was receiving from women acceptance and open-armed enthusiasm."

When Schapiro and her husband moved back to New York City in 1975, they bought a loft in the heart of the SoHo downtown artists' district. Schapiro intentionally created artworks from traditionally "female" fabric and methods, and soon became a leader in the contemporary art movement based on decorative, often anonymous traditions, called "Pattern and Decoration." "My work in 'Pattern and Decoration' was just gobbled up in Europe," notes Schapiro. "I sold my whole production one year and this was the beginning of real financial success and an international career." The female figure has appeared whole and fully articulated, for the first time since Schapiro's earliest paintings, in her work of the past several years. Schapiro also plumbs the meaning of art history for women. Within her layered compositions, she incorporates references to women's position in, and contribution to, art history. She even conceived of her relationship to the 19th-century post-Impressionist painter, Mary Cassatt, as a "collaboration," and executed a series of works in 1976 that featured "Mary Cassatt and Me." Recent work includes a series of paintings that pay hommage to the Mexican artist Frida Kahlo.

"Revisionist art history that would incorporate the contributions of women has just barely begun," notes Schapiro. "We female artists, critics, journalists, art historians, must stick together. If we don't voice what we're feeling, thinking and experiencing, we'll never educate the public and there will continue to be a one-sided view of what mainstream art is. My philosophy is always to keep mainstream thinking open to the thinking of 'the others.'"–A.R.

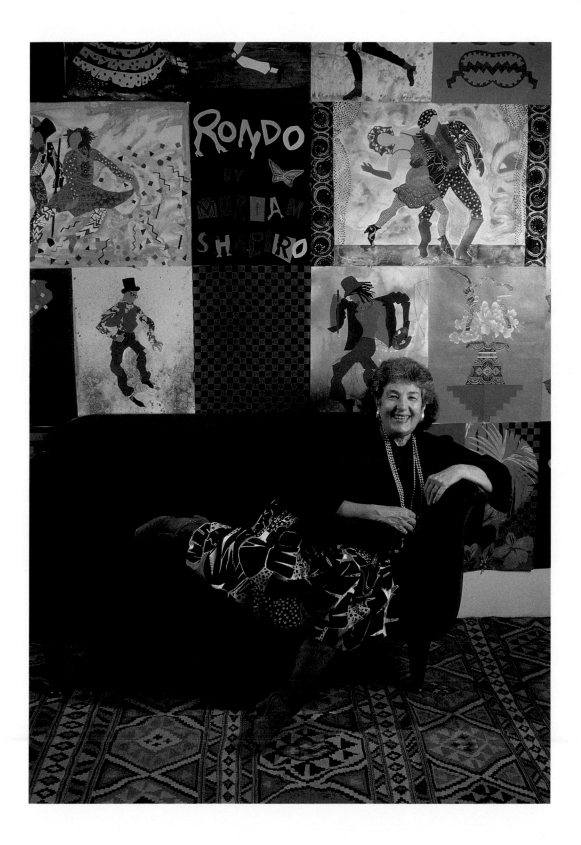

Deborah Remington looks at the world from the inside of her paintings. Along with the writer, Franz Kafka, Remington knows that even the most solitary soul needs a "street window" to the human harmony of the world outside. And that window, for Remington, must be made with the enlightening luminosity of paint. Her unwavering pursuit of her art has manifested itself in a biography of single-minded dedication. Seeing has always been the most important element of Remington's life. Born in Haddonfield, New Jersey, in 1935, she was the only child of a stockbroker father and homemaker mother. Remington grew up with encouragement to be an artist from both parents: "I had private art lessons at eight, and was sent to the Philadelphia School of Industrial Art on Saturdays when I was nine." As a high school student in Pasadena, California, she was already immersed in art classes. "My mother took me to museums and churches when I was a girl. I grew up with a curiosity about looking and visual learning."

Remington's art heritage is abstract expressionist painting of the San Francisco Bay area. "I studied painting with Clifford Still, David Park, Elmer Bischoff and Hassel Smith at the San Francisco Art Institute during the 1950s and early 60s," explains Remington. Even within the iconoclastic avant-garde atmosphere of the school, Remington took a singular stance. "After my sophomore year, I saw that representation was not my direction. My imagination was too grand. I didn't want to be stuck with shapes that already existed," she insists. "I wanted my own shapes and space. I love to break rules like creating deep space when contemporary painting is supposed to contain only shallow space. Or making the horizon line in the middle of the canvas, then directing your eye away and back to that fact with perceptual tricks." Wide-spaced landscapes saturated with light and surreal forms filtered into Remington's earliest efforts, later to be seared and refined into emblems that documented her struggle by containing the compressed energy of the synthesizing process. Remington's oppositions of colors and tones strained her spaces to their limits and finally could convey the limitlessness of imagination she had sought to express.

After graduating from the San Francisco Art Institute, Remington spent three years in Japan and Southeast Asia. "I went to get life experience. I couldn't make interesting pictures if I wasn't an interesting person," she explains. Remington worked as an actress, language tutor and cook to pay her way. "Tall and blonde, I put myself in the visually alien territory of shorter, dark-haired people." Remington studied intensively classical and contemporary Japanese calligraphy while living in Japan. Her accomplishment in the precise lines of her paintings after that time can be partly traced to the demanding exercises of her calligraphy masters. Remington's sense of the isolated image floating in the center of a sea of finely textured paint also reflects a Japanese influence.

In 1965, Remington says she returned to New York in order "to get back to my roots on the East Coast," where in the 1970s, she created the work for which she is best known. Her forms fell away from the edges of her pictures, and single icons suffused with a crystalline light from unlikely sources and perspectives emerged. The surfaces of her paintings were now made by applying thinned paint in many even layers instead of thickly brushed, animated strokes. Cool, convex, mirror-like shapes, forms like metal holding emptiness, became her distinctive mark. More recently, her color is still as burning-cold as her machine-like images of the 1970s, but her paint is hardier and somehow more evocative though not descriptive of everyday objects. In 1985, Remington was working on drawings which let in something of the outdoors—plants, fragments of what could be seen from windows, the ambience of painting in the open air of the Pennsylvania countryside. The paintings that followed these generative works on paper, shown in New York two years later, are "painters' paintings"—luscious, restrained, masterly models of her medium.

In the 1980s, Remington has taken up stroke, paint substance and formal plays on the commonplace of inside and outside, where she left these issues in 1963. As if back-lit by street lamps and neon through a shade, these recent paintings throw eerie but friendly light on themselves. Evidence of the artist's hand has returned. In the mirror reflections of Remington's paintings, the background of the viewer's world becomes foreground, subject. In her tensely constructed environments, where nothing exists without thought and reason, and the human form burns with internal fire, a dazzling physical and spiritual universe can be sought and found.–A.R.

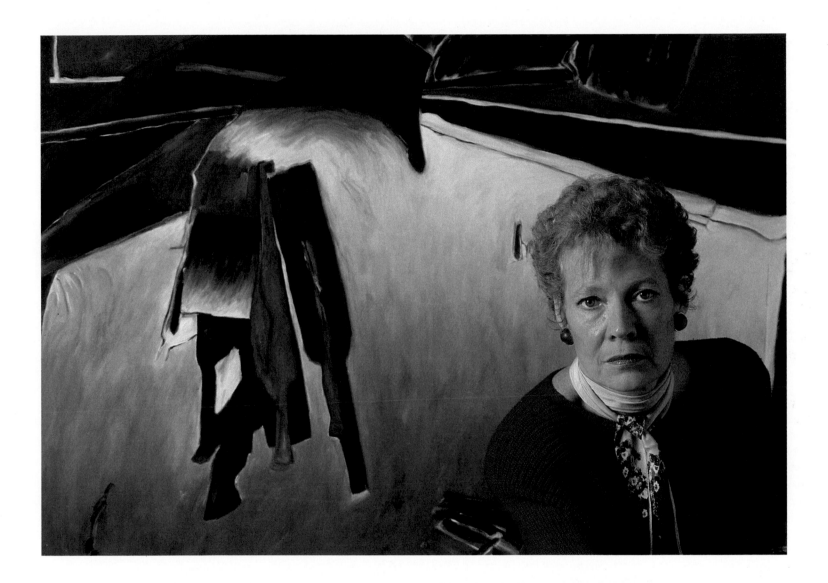

"I am a portrait painter in every way," asserts Sylvia Sleigh. "Even if I paint a leaf, it should be a portrait. It is my belief that if we could all appreciate every living thing in detail, we would be kinder and better to one another." Sleigh's most memorable group portrait may be "The Turkish Bath" (1973), named for French classicist Jean-Auguste Dominique Ingres' famous 1863 painting of harem women. Unlike Ingres' sensuous slaves, painted with a love of the flesh but little regard for the unique identities of his subjects, Sleigh's six naked men are all recognizable art-world personalities, including Lawrence Alloway, a distinguished art critic and the artist's husband. "I tried to do for the men," she said, "what I thought should have been done for the women."

Sleigh was influenced by art historian Linda Nochlin's analysis of the concubines of Ingres' "The Turkish Bath" as "brainless body parts." Nochlin, to illustrate a disparity in portrayals of men and women, also had published a "role reversal" photograph of a male Vassar student, naked but for his shoes and socks, offering bananas from a tray at penis level. Nochlin's image parodied 19th-century photographs of half-naked women holding platters of apples at breast level. Sleigh's adaptations of "grand manner" paintings of the past, as well as her single portraits of friends and colleagues, are not role reversals themselves. "I want to present the men as well as the women in my paintings as individuals of whom I'm very fond, and who deserve special respect," notes Sleigh.

Sleigh, who was born in North Wales, England, was influenced by her mother who painted and wrote poetry. "Of course she was an amateur," notes Sleigh. "English ladies couldn't do it any other way, but she did win a bronze medal at the Poet's Club in London." Sleigh remembers looking through her mother's large collection of art books when she was very young. "At an early age I'd seen all the important masterpieces in reproduction, and when I was 14, my mother gave me my first oil colors." Sleigh's mother left for South Africa when Sylvia was eight years old and returned five years later on the death of Sleigh's grandfather. "During those five years, I was brought up by my Granny, who left me in the care of nurses. I was a lonely child," admits Sleigh. "But my mother had been a great story teller. Her romantic tales activated my imagination and sent me into mad reveries!" While attending high school in England and later Italy, two female teachers encouraged Sleigh's artistic efforts. She went on to Brighton Art School in Sussex, where she studied portrait painting and commercial art. At Brighton, Sleigh was thoroughly discouraged by faculty members. "So I gave up art, but I was miserable." Unhappy, Sleigh saw a psychologist and after six months, he asked her what she really wanted to do. "I said I'd like to be a painter. He replied, 'Go paint!'"

Sleigh says she studied portraiture and commercial art because "I knew I had to earn my own living. I thought I'd be an old maid if I took a teaching course because teachers didn't seem to marry." To the contrary, Sleigh has since been married twice. "My relationship with my second husband, Lawrence Alloway, saved me," says Sleigh. "I had no confidence at that time, but Lawrence cheered me tremendously. He reviewed my first show in London and even bought a piece." Alloway also has been Sleigh's faithful sitter and in 1983 Sleigh exhibited a retrospective of paintings and drawings of Alloway she created from 1948 through 1980. In 1961, Sleigh and Alloway emigrated to the United States. Sleigh joined other artists in New York a decade later in the Ad Hoc Women Artists Committee, Women in the Arts, SOHO 20 and A.I.R. Gallery. Sleigh's collective portrait of members of the A.I.R. women's cooperative gallery in 1978 remains an important document of the New York women's art movement.

Sleigh's romanticism is at its grandest in "Invitation to a Voyage: The Hudson River at Fishkill," a major work in progress since 1979 consisting of 15 panels arranged in a 25-by-15-foot rectangle. "I fell in love with the island and its castle more than 20 years ago, when Lawrence and I first came to New York," explains Sleigh. Bannerman's Island Arsenal became the romantic ruin Sleigh painted as her "enchanted castle" in the center background of the first five panels of her monumental landscape. In "Invitation to a Voyage," familiar figures that have appeared in Sleigh's works over the years picnic on the edge of the water, delicately frozen in time. A viewer actually can enter the scene and stroll among the friends. Approaching the fourth panel, Alloway, who has been confined to a wheelchair for several years, can be seen standing next to Sleigh. In this panel, Sleigh rises to her feet and grasps Alloway's outstretched hand. –A.R.

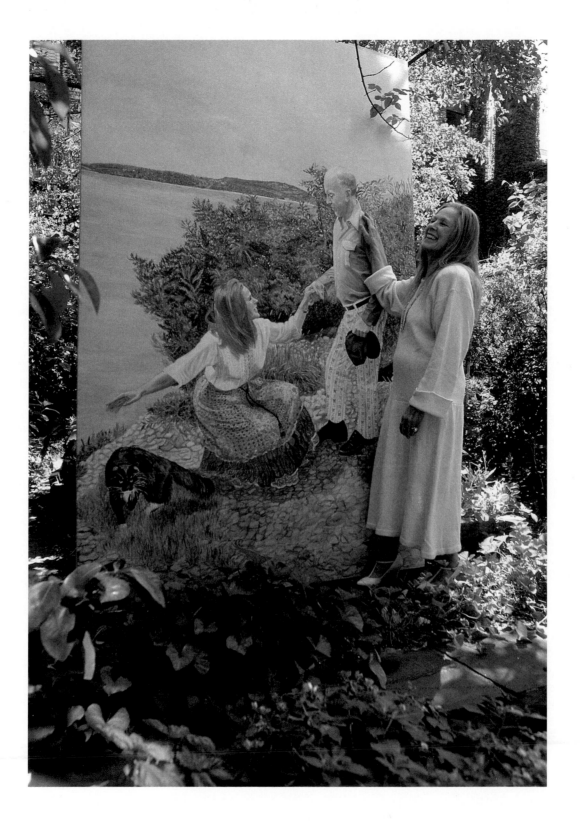

In June of 1982, Sharon Kopriva backpacked from Cuzco, Peru, to Macchu Picchu to see the archaeological ruins high in the Andes that some scholars think was the last stronghold of the Incas. As she climbed through "Dead Woman's Pass," the third, high-altitude pass on the old Inca road, Kopriva got her first glimpse of the awe-inspiring site. High upon the rugged cliffs stood a city of stone once filled with bones and relics, now stripped to its raw granite geometry. On one side of the dark, irregular rectangles of stone, lush tropical foliage tumbled down the steep inclines. On the other side, desert-like dryness had turned the cliffs a deep, sandy brown. "I felt like I was stepping into one of my paintings," Kopriva remembers.

Life and death, growth and decay, vitality and ruin have always been the themes of Kopriva's art. They are intense, sometimes difficult themes, that often challenge viewers. Kopriva got a sense of just how disconcerting her art could be during a critique of her graduate work at the University of Houston, where she received her master of fine arts degree in 1981. At that time, Kopriva was painting expansive landscapes with abstract flying bone and rock images. One of her teachers protested, "But there's no place like that! That doesn't feel real!" Kopriva knew differently; she knew there were places where bones and rocks marked the sacred significance of the earth or as remnants of apocalyptic destruction, so it was validating to find such places in Peru.

The pre-Columbian mummies in Peruvian museums also influenced Kopriva's work. The ancient Incas, like their predecessors in the Andes, buried the honored dead wrapped in yards upon yards of finely woven cloth. The mummy bundles were given masks—gold masks if the person had attained high rank—and adorned with jewelry. Kopriva paints images inspired by the Peruvian mummies, depicting ghostly figures swaddled in fabric, floating in spectral realms. She also constructs her own sculpted versions of such mummies from animal bones, gauze, papier mache, wood and paint. Kopriva's sculpture, "Boatbound," is a mummy encased in an elliptical ship. Beads dangle from the mummy's recessed head. Broad, white bones cross the ship at its chest and knees. It is a figure on a journey, a traveler from life to afterlife. Another sculpture, "Rootwoman," is a mummy wrapped in a shroud of roots and twigs. The basketry arch that holds her head looks like a halo. Her stomach bulges, she is pregnant with new life. Yet her skull has taut, dessicated skin and only remnants of gray hair. Somehow, the beauty of the rich surfaces and the poetic symbolism of the objects deflates their ostensibly morbid character. "These are transformations," asserts the artist. "They are bodies transforming from life to afterlife. I am afraid of death, but also fascinated by it. Death is not an end, but part of a cycle—there is continuation, rebirth."

Kopriva is fascinated by the faith of her parents, who were Italian Catholics, and this religious heritage strongly influences her art. She began a series of martyr mummies in 1984. "Sebastian" is an emaciated figure whose hands are drawn tightly together over his head. Naked, stripped of his clothes and most of his flesh, he has been riddled with the arrows that project, painfully, from his torso and limbs. "Agnes" is darker; the ghostly figure bends against the weight of crosses, chains and nightmarish animals. Painting "Agnes" was particularly important for Kopriva: "The nuns told us about her when we were reaching puberty, to keep us pure. Agnes was martyred by being cut open, stuffed with straw, then fed to the beasts."

While traversing the images of Catholicism, Kopriva also has created a series of madonnas. Her spectral "Black Madonna" shines with unearthly, silvery light, while hordes of skeletal celebrants erect flaming crosses before her. She becomes the focus of mysterious supernatural rituals. Kopriva's "Madonna of Lourdes" shimmers in a pearly, translucent aureole above a velvety black mountain marked by three crucifixes. She is powerfully beneficent, like the warm glow of the full moon, and seems to offer eternal peace.

Kopriva's images of female martyrs and madonnas began with a large painting she calls "Rose of Sharon." "It began as a painting about my mother," explains Kopriva. "There was a figure coming out of a rose, which became a lily, then a cocoon, representing my relationship to my aging mother. It was also about my own aging; I had just turned 40." She adds, "A lot of my work, like 'Rose of Sharon,' is about the body going from flesh to spirit. Even my mummies are not about an end, but about what's left when the spirit departs." As her work unfolds, Kopriva sees that she is dealing with universals that surpass cultural and time frames. In her explicit, even grisly, images of death, Kopriva finds metaphors of the hope for continuing life. –B.A.B.

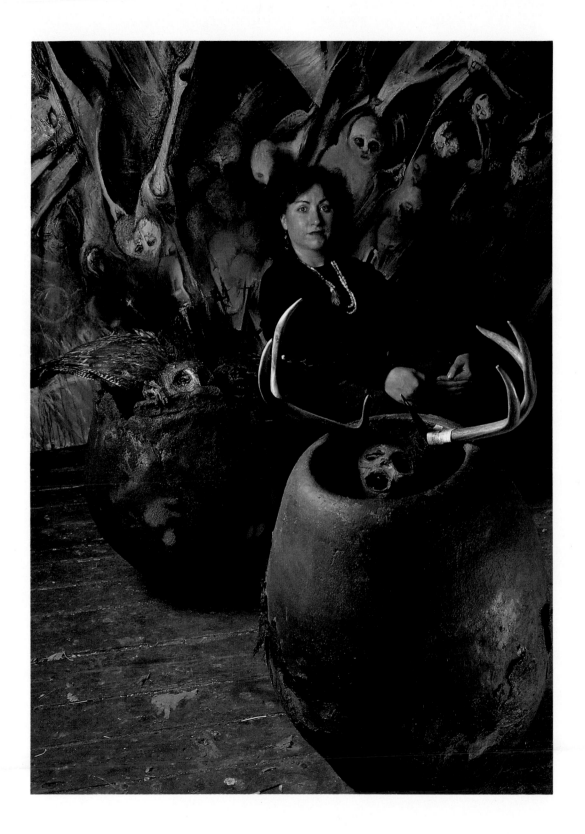

Younhee Paik creates large, abstract paintings that depict cosmic spiritual quests. She paints huge banks of clouds that surge with cosmic energy through luminous layers of colored space. Molten masses rise, then vaporize in sizzling stellar alchemy. Radiant expanses of gas-saturated atmosphere are crossed by mysterious black cubes or pierced by pyramidal flights of stairs. Thick planks shoot through the waves of watered air, rapid and aggressive, yet strangely peaceful.

"The plank in my paintings and monotypes represents myself plunging into the flow of time and space," explains Paik. "It is a spirit having left the body free from worldly encumbrances. The planks float in space searching for the greater unknown world like birds flying across many lands."

The planks soar toward mirrored planes that reflect the marbled undulations of clouds; they cross the shadowed curves of immense spheres; they dare to enter horizons threatened by weighty boulders. These are the images of space travel, of the uncharted physical realms that hold humanity's hopes and fantasies. But they are also the maps of spiritual travel, of one soul traversing the infinite space behind the eyes. Paik is attuned to the correspondence between inner and outer space. "I like to think about the source or power of the universe," states Paik. "Both art and life are derived from the power which reigns in the universe. I believe that power is truth. All beauty comes from the truth that has always been." She adds, "I don't create art or create beauty, I just discover what has always been there."

Nature is an important source for Paik; she knows she is part of it. Although inspired by the flow of sky and water, Paik does not depict the world perceived by the senses. Rather, her work and her vision evoke the powerful forces that are the underlying truths of the universe. Paik conjures up the wonder-wrought realm of discovery, recognition, epiphany, as her luscious waves of color meet angular abstract forms. The flowing processes of nature seem to encounter the physical realities of eternal truths as embodied in geometry. Paik would agree with the Franciscan monk Roger Bacon who, in the thirteenth century, exclaimed, "Oh, how the ineffable beauty of divine wisdom would shine and infinite beauty would overflow, if these matters relating to geometry should be placed before our eyes in their physical form!"

This seeker of ethereal truth in art was born in Seoul, Korea, and realized as a very young child that she was an artist. "I always liked to draw; my mother knew I could really concentrate when I drew," recalls Paik. Her rapt concentration was quite apparent by age 13 when, one day, while drawing in the studio space she shared with about 20 other young people, she totally lost sense of the time. She sat quietly hunched over her drawing as the janitor locked up the building and turned out the lights. It wasn't until long after midnight, when it finally was quiet on the street, that the guards on the floor below heard her screams for help and came to let her out. Paik raced home to parents who feared she'd been kidnaped.

Paik attended Korea's only arts high school and then went to the Art College of the National University in Seoul. She decided to come to the United States to further her art studies. "I thought Korea was a small country. I wanted to see a bigger world." It was at the Art Institute of San Francisco that Paik finally began to take herself seriously as an artist. "The Art Institute really made me think I had to make a career, make a life as an artist," explains Paik. "Just the atmosphere there made me think more about art."

Paik's newest transition as an artist came about after a summer stay in Europe. She realized that while she has been dealing with subjects that are "quite heavy and serious," her surfaces were often "pretty." Paik's new work, while still depicting nature's elements, is more bold. There is more action and movement in her powerful forms, more texture and depth in the paint. "My art is not fun or entertaining," observes Paik. "There is beauty but also violence in this vast space and time we occupy. We are such a tiny part of the vastness, but I try to understand what is the power and beauty that has existed from the beginning of time—and my part in it. Some people think my art is too heavy, but I want to know. I want to know the mystery of life."–B.A.B.

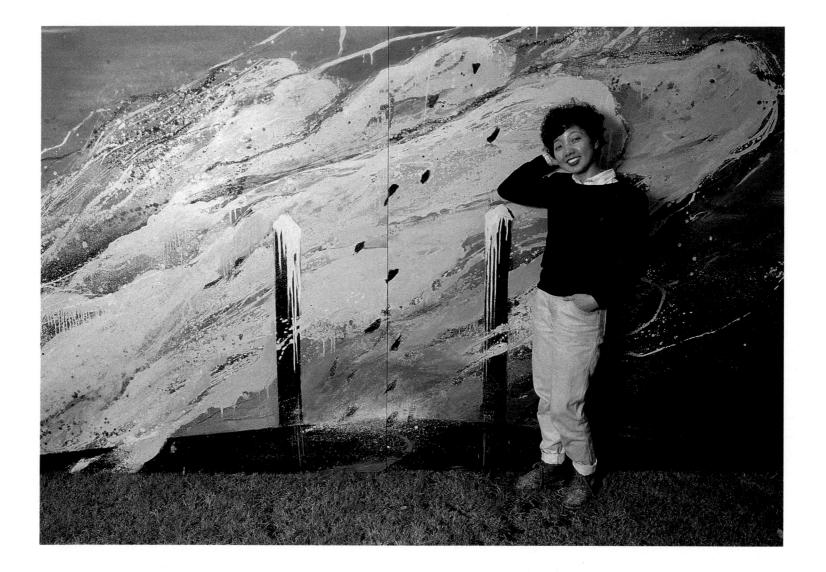

"My paintings are not political protests; they are memorials," states Connie Jenkins. "I create monuments of these events, trying to process them. When someone dies, you mourn. You feel anger, depression. Then you have to transcend that and recognize the continuity of life. My art is about that mourning cycle in a global sense."

Jenkins combines the technical exactitude of photorealist painting with ardent political commitment. She has used images of stones on sandy beaches to represent the fragility of each human life, and clusters of bones strewn over volcanic rock to symbolize the horrific finality of death. The stones on the beaches were conceived as ritualistic allusions to the Salvadoran peasants, many of them children, lost in army massacres of the early 1980s; the bones on pitted volcanic boulders refer to the death squads of Central America.

The integration of art and social engagement has not always been easy for Jenkins. Throughout her graduate work in Colorado, Jenkins was intrigued by two developments in contemporary art. She was drawn to the skillful precision of superreal painting and to the engaging action of environmental sculpture, which employs the earth's places and materials as its media. She began collecting creek stones and polished spheres from rock quarries, piling them into small pyramids, then painting them. Her paintings were so expertly executed that they fooled the viewer's eye—they looked like oversized photographs rather than paintings.

Jenkins moved to California in the early 1970s where she had a one-person exhibition at the Municipal Art Gallery in Los Angeles' Barnsdall park. At that time, her personal life was moving in a more political direction. The mother of two children, she found herself becoming involved with school desegregation. By the time of her Barnsdall exhibition, Jenkins was beginning to feel a schism: "I felt real schizophrenic going into my studio and doing something that didn't have anything to do with my personal life," admits Jenkins. "At the same time, the Women's Movement was stressing the connection between life and art, which of course had been banned for over a decade by the Minimalist School; formalist painting didn't permit personal engagement. So I started looking at the materials I was using in my art and trying to think about how I could use them to portray some kind of social/political information."

One day, after hearing the agonizing news about yet more deaths of young children in Atlanta, Jenkins took a walk along the beach near her home. She gathered black stones from the shore and arranged them in a circle. Then she added two white stones for her two children. As Jenkins watched the tide cover the stones with sand, she realized she had created her own ceremony, a burial rite for the victims of those senseless killings. Later, Jenkins repeated the ritual laying out of the stones, photographed them and generated three paintings as a memorial. She included a final stone for the man accused of the killings, as she felt that he, too, was a victim. Weeks later, she heard of an incident in El Salvador in which 28 people—men, women and children—were dragged out of their homes, decapitated and left in a ditch. The number 28 caught her attention. Like the killings in Atlanta, there seemed to be no explanation for these senseless deaths. Jenkins returned to the beach, lined up 28 stones in a row like a firing squad, and photographed them as the gentle but inexorable tide pulled them out of line. The Atlanta and El Salvador paintings made Jenkins aware of the frequency of such incidents. She began to use her art as a way to record these events and to acknowledge their effect. As she painted, she researched. Jenkins learned more about United States intervention in Central America. "I learned about countless atrocities that the U.S. press didn't report because Americans don't want to hear about them," says Jenkins. "We would feel too guilty."

Jenkins' newest paintings are inspired by a trip to El Playon, an area just north of the capital of El Salvador that has become an open graveyard. Similar to the "Killing Fields" of Cambodia, El Playon is a site where Salvadoran death squads have dumped the bodies of their countless victims. Jenkins' paintings are not about specific events, nor are they reproductions of what is actually at El Playon. "They are more my imaginary sense of what the place would be like if they hadn't removed all the bodies," she explains. "I visited some volcanic outcroppings in the California desert and found one that fit my mental image of what I wanted—the drama of it. I got some skeletons and I went out and placed them and took photos, which was one of the eeriest things I've ever done." Jenkins considers the paintings of skeletons and volcanic stone morbid and apocalyptic, but also visionary. "We're destroying ourselves through this cycle of violence," states Jenkins. "We're destroying this world, putting it at risk. I'm projecting a landscape of the future—this is the crop we could reap."–B.A.B.

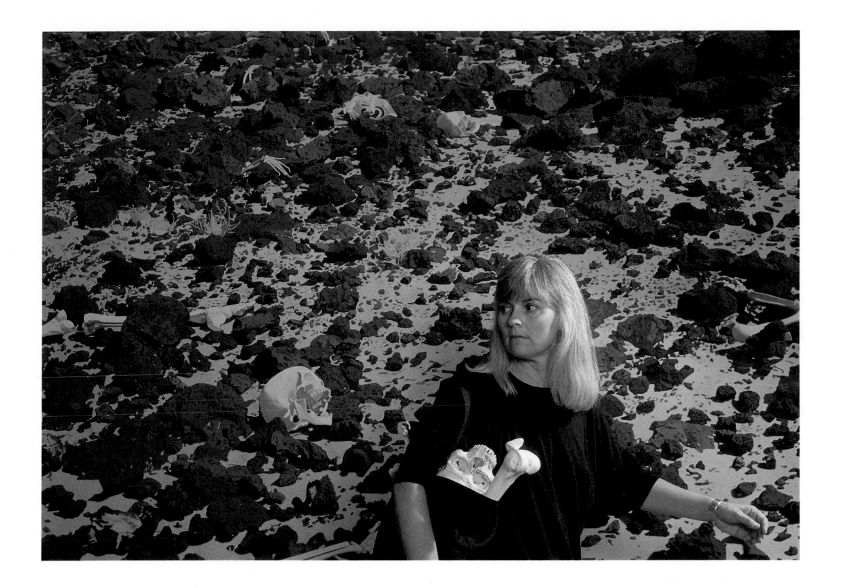

Margaret Wharton's capricious and insightful art explores the material and metaphorical natures of manufactured objects, most often chairs and books. She takes chairs apart and saws into each wooden component to carve thin layers, like the skins of onions, out of the chairs' interiors. Then she reassembles the chairs in a whimsical manner, fanning the wooden intestines over a gallery wall, weaving them together with ribbons and buttons, turning the fragile slats and legs and rocker curves into ships or idols or human figures. By combining a lively imagination and excellent craft skills, Wharton evokes delight and fantasy from a common piece of household furniture.

At other times, Wharton applies her band saw to the insides of books. She pulls layer after laminated layer from the bulging interiors of encyclopedias, then arranges the thin sculptural sheets into assemblages that are poetic, humorous or poignant. She cuts up a legal tome ("The Federal Court," second edition) by the Black American writer, Richard Wright, and the hefty St. James Bible to transform them into a bar bell. Smiling mischievously, she makes the pun explicit: "Bar refers to the law profession in which Blacks were often not treated 'rightly' and bells are what call people to worship." She underlines her literary whimsy by naming the piece "Exercising Your Rights." Wharton approaches both books and chairs with the same attitude. "I'm very good at rearranging things. I start with a recognizable object, then challenge myself to rearrange it in a meaningful way. My work with chairs requires a concentration of form and matter. With books I bring language in and that can be a major portion of my thinking. It's also my way of researching what interests me."

"The Search for God" is a piece in which the innards of a Bible have been hollowed out and filled with numerous compasses. Each compass points in a different direction. Viewers who turn the book over to consider this magnetic anomaly, see their own faces reflected on the mirrored backs of the compasses. "I don't plan all of this," admits Wharton. "I make something, see what I've made and then look terms up in dictionaries and encyclopedias." All the forms she uses have histories, associations, meanings. She subverts them, juxtaposes them, inverts them in order to challenge the viewer's understanding of those meanings.

The sophistication and delight of Wharton's work belie the relative difficulty she experienced in coming to such artistic expression. "I made things all my life," she remembers, "but I was a latecomer to art as a profession." Wharton was born in Portsmouth, Virginia, and educated at the University of Maryland. She moved to Chicago because of her first husband's work. "I came as 'bag and baggage' but soon began to feel that life was boring," Wharton explains. "I wanted to get something interesting going, so I started taking classes at the Art Institute of Chicago. I didn't have any idea that I would end up a professional." She completed her master's degree in 1975 and by that time was already creating art from chairs. "I'd take a chair, cut it two dimensionally, flatten out its slabs or sections, then rearrange it," explains Wharton. "Or I'd take a chair and hollow it out, take the inside out, then the inside of the inside out, then do it again, so I could spread it out."

Wharton's interest in the history of art inspired her to create a piece that employs the famous photograph of French artist Marcel Duchamp playing chess in an art gallery with his nude model/muse. Facing the photograph is its negative, in which the nude woman becomes a powerful, almost ghostly, presence. Both the photograph and its negative are inside a book called "The Daily Double." The title indicates the piece is an ironic commentary on the way male artists have traditionally treated their model/collaborators and on the culturally defined limits of sexual identity. Throughout the history of Euro-American art, men have most often been depicted clothed whereas women have most often been depicted nude—as passive objects for the spectator's consumption. Reversing the black/white of photographic positive and negative challenges the viewer to reverse the active/clothed view of males and the passive/nude view of female.

"My work is an aesthetic record of mental discourse," explains Wharton. "It is the result of the combined forces of intuition and intellect working through the manipulation of matter. It is intended to surprise, delight and in some instances, engage the viewer in solemn thought." Happily, Margaret Wharton clothes her concepts in attractive form and spices them with humor, so that viewers are drawn in, totally engaged, before they even realize she has served up many levels of intellectual challenge for consideration. –B.A.B.

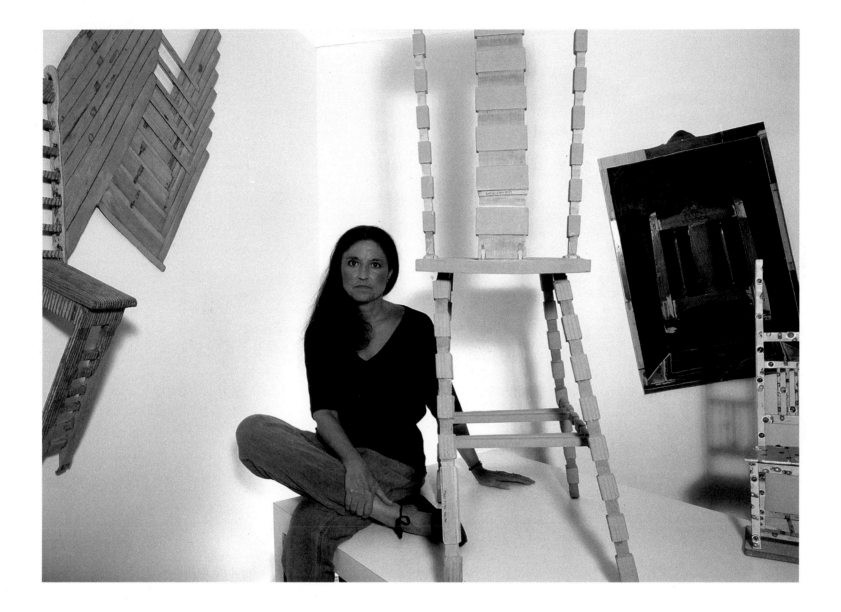

After completing the arduous training required for the bachelor of fine arts and master of fine arts degrees in painting, and after attaining a high level of technical and conceptual sophistication in her medium, Hollis Sigler began drawing like a child again. She was compelled to do so by an emotional crisis in the early 1970s. "All the facets of my life that I hadn't paid attention to started screaming for attention," explains Sigler. "I was at the end of my 20s; I began to think about relationships and the emotional quality of life. I realized I had to take care of things I had buried, so I ended up in therapy. I also started keeping sketchbook diaries and I began writing things down, dialoguing with myself."

All of Sigler's work since then has been influenced by her diaries. "I suddenly felt there was a hole in my personality that didn't have a means to express itself," she admits. "The drawings gave a voice to that hole, filling it the only way I knew how." She began by doing childlike drawings of the objects and interior spaces she remembered from her childhood. She used graphite, then added oil pastel, because pencils and crayons were the materials she had used as a child. She started with houses from her childhood, added sites she had recently visited, then rooms in her current home. Later she began to incorporate narratives, bits of memory, sometimes events happening at the moment. The stories were about feelings—not the specific causes of feelings, but about their reality and power.

Sigler hesitated to show her diaries or the drawings that developed out of them to anybody, because such images didn't satisfy the art world's definition of what art should be. She credits the Women's Movement with giving her the courage to bring her new, highly subjective art to a public forum. "I had gotten involved with the Women's Movement as an undergraduate at Moore College of Art in Philadelphia" recalls Sigler. "It seemed so right; it had answers to feelings many of us had, but I internalized it and didn't bring it forward in graduate school at the Art Institute of Chicago." After graduating, Sigler joined the Chicago women's cooperative Artemisia. Her talks with the outspoken artists in the cooperative and her participation in their conferences were transforming. "Being actively involved in the women's community was really important in allowing me to do this work," says Sigler. "It forced me to come face to face with myself and try to be authentic."

Sigler paints rooms that appear splayed open, vulnerable to our gaze. Chairs, beds, clothes imply a female protagonist who seems to have just walked out of the room, leaving it vibrating with the passionate impact of her presence. Love letters are scattered over a midnight blue floor, red gloves stretch a necklace taut. A fur coat is consumed by shimmering,

pointed flames. Refrigerators, lamps, televisions are circled by pearly halos. Curtains flutter in the wake of the absent actress. We see the ravages of passion, but not its object. Sigler explains that her paintings are "about our destinies, about how we are being led by irrational qualities—our desires, passions, fears—into situations outside our control . . . and about how electrifying that can be." She adds, "When you fall in love with someone, how much control do you have over that? You feel flooded, swept away. That loss of control can be scary, but also passionate, exciting, hot." She paints a tornado coming off a bed, and male and female clothes spiraling around it. The clothes become both symbols for lovers and for the merging of male and female parts of an individual.

Sigler wants the implied female presence to represent Everywoman. She doesn't portray specific figures because she doesn't want them to be identifiable with specific features such as skin color, hair color or age. "I think we all experience very much the same things," observes Sigler. "We feel betrayed at times, happy other times. The causes may be different, but I think the effects are the same." For this reason, Sigler tries not to talk too much about the specific causes of her images. "I don't feel it's necessary that people know where it comes from in my personal life, but rather that they think about it in their own lives." Sometimes specific events are so powerful and transforming that they create particularly resonant images. In 1985, Sigler traveled to North Carolina to do a series of prints at a workshop. She saw trees wrapped in Virginia creeper and kudzu vines, wrapped so completely and so tightly that the trees were killed. At the same time, Sigler was undergoing chemotherapy treatments for cancer. The images of the vines touched her deeply. She did a painting entitled "Drawing from Life," in which a heart lays open on a bed. Veins emerge from the heart, crawl across the sheets, metamorphize into vines, then climb onto nearby trees. The vines had become for Sigler a metaphor for giving oneself a kind of poison to cure something bad. She has taken a painfully personal experience and, with the transformative power of art, moved it from separate and subjective to shared and universal. "In doing my art, I have found the personal is important," states Sigler. "It's the glue that keeps us all together."
–B.A.B.

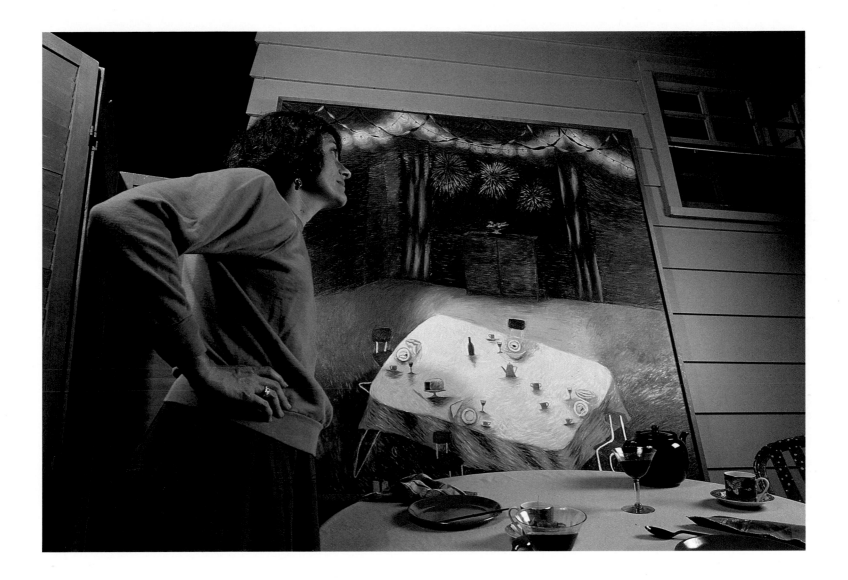

Nancy Bowen had just graduated from the Art Institute of Chicago in the mid-1970s when she first fashioned a female figure. "I'd been making completely abstract tableaux—narrations of personal dreams, stories about myself as a woman and fantastic reconstructions of my interactions with people," Bowen explains. "The climate of the women's movement encouraged me to become more specific and clear. I began to use the recognizable forms of female statues." Even her earliest efforts embodied a potency and vigor that was to empower her subsequent three-dimensional feminine images.

Bowen grew up with the feminist art movement, and credits feminism with inspiring her to seek a lexicon of strength and beauty in her environments and sculptures of women as well as abstractions of female form. She has found her vocabulary by degrees, through investigating configurations of the internal and external body, and by translating the grandeur of the feminine into a monumentality of both dimensions and proportions. Her sculpted torsos and heads of the 1980s have become progressively larger in size and even larger in scale than her previous work: Body parts suggest gigantic figures.

The liveliness of Bowen's figures was especially apparent in an eight-year survey of her work in 1987. In the exhibition, her sculpted heads seemed to rise from the carpeted floor of the gallery or lay marooned as if stuck to it in mid-crash. Vigorous females flung themselves from the wall with provocative gestures. Others back-flipped, landing belly-up on all fours on urns. "I engage with my sculptures on an intensely physical level," notes Bowen. "I match my body and energy against the sculptures. And I want to make something a viewer feels physically as well as intellectually or emotionally and has to contend with—a head you can't just step over."

Bowen made shaped, mixed-media wall constructions between 1979 and 1981, which prefigure her grand-scale plaster, terra cotta and casein heads. The shapes of her most recent large sculptures are outer surfaces of internal organs, descended from her 1979 bas-relief rooms and fragments of architecture, statuary, ceramics and bracing schematic frames. Bowen has explored female sexuality in depth in her work, guided by the new insights about women's biology and experience brought to the attention of the public by contemporary psychologists, literary critics and health care professionals. She has also been inspired by modern artists who have rendered the female form in three dimensions. "I'm working out of an experiential knowledge of my body, of both pleasure and pain," she explains. " But there are certain paradoxes. For all of the vast medical and analytical advances being made, my own experience of my body remains very primitive and biological. In the history of the world, no one has developed a philosophy of the body."

In some ways, Bowen's clay sculptures recall Louise Bourgeois' interpretations of the "Femme Maison" during the 1940s. In Bourgeois' series of drawings, a woman's body, her "temple of the spirit," merges with her material house in a single image. "Femme Maison" became an emblem for the housewife who would be so thoroughly addressed and analyzed by American writers like Betty Friedan during the 1960s and 1970s. Bowen's clay sculptures also merge woman and home. Each is not alone a model for femininity, but for some aspect of the female. Identification with the home of even one's own body today, Bowen has shown, will never be the simple analogy possible 40 years ago. Rapidly shifting circumstances and values complicate female sexuality for Bowen's generation, who grew up with mandates for greater responsibility to "our bodies/ourselves." Bowen, once a Stanford University architecture student, has made what she calls "an architecture of the body." Bowen presents the body in parts, still split hopelessly from mind and spirit, where fear and horror of amputation merges with the excitement of sexual anticipation.

"Housed" in the biomorphic idiom of the earlier 20th century and the three-dimensional work of older artists like Constantin Brancusi, Henry Moore and Louise Bourgeois, Bowen's sculptures also must live in today's chaotic contradictions. "The forms are all there to be re-combined," she says. Bowen's reconstructions are bionic. She is fashioning a new hyphenated atlas that includes the past and present together. Variations on the known forms of modernist abstraction are recapitulated into new inventions that burst the boundaries of their references. Bowen's sculpture explores sexual complexity with a heated self-consciousness and awareness that most people are still afraid to see straight on. –A.R.

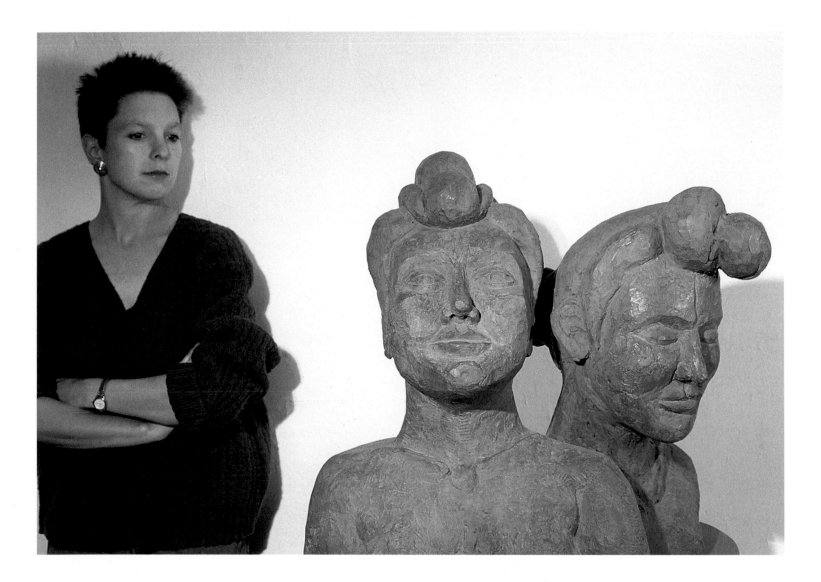

Ruth Weisberg feels the rush of time. She is very aware of the past and of the fleeting moment she occupies in the present. Her paintings record her passions, memories, dreams; they are eternal images of the ephemeral. Weisberg is an artist who contemplates her place in history, and acknowledges the many artistic and cultural traditions to which she is heir. She explores her religious heritage to generate images of what it means to be a Jew in late 20th century America and examines her role as a woman to depict the female in wide-ranging, often unprecedented contexts. Weisberg studies the paintings of Old Masters such as the 17th-century Spaniard Velazquez and the 15th-century Italian Masaccio, and incorporates quotations from these artists into her own work. "I feel in the presence of art this intense extra layer that was given me to live through," she asserts. "I have always felt that I've lived my life with all these extra images and experiences from other minds. I've got Goya's mind and Rembrandt's mind, Kathe Kollwitz's mind. I have access to all those other great visions of humanity, of nature, of order. I want to be among them. I want to add my voice, my vision."

Weisberg has focused on her identity as a physically vulnerable, temporally bound individual, especially since she had cancer. She has moved through her personal memories to paint herself as a child playing "Indians" on the Indiana sand dunes, or to portray her own two children standing beside the elevated train she rode to attend art classes in downtown Chicago. She has also explored her Jewish history, creating images of her lost ancestors standing shadow-like before the Great Synagogue at Danzig or the empty striped uniform hanging outside German gas chambers. In her "Circle of Life" series, Weisberg images friends dancing on the dream-like sheen of a white beach. In "Waterborne," she depicts herself pregnant and floating, fetally curved, in a blue pool. Finally, she paints herself as Everywoman passing through the open, dark door to death.

Although Weisberg bases her compositions on traditional academic drawing, her shimmering curtains of light and the deep cavernous shadows give her paintings a poetic quality that is quite modern. She often paints on unstretched canvas, so the images hang like silken tapestries with glazed reflections of midday blue and its evocative opposite, fiery orange, rippling over their surfaces. Because Weisberg combines images from different places and times in single framed segments and juxtaposes scenes that are not logically or narratively linked, she eludes any linear or illustrative mode. Even as Weisberg insists on finding her own moment and her own space in time, her paintings become timeless. Her art is an impassioned attempt to forestall the inexorable movement of life toward death.

Weisberg has sought the meaning of life in the lessons of her ancient religion, and has found a mentor in Rabbi Laura Geller. Geller, the director of the Hillel Center at the University of Southern California, has worked to write the austere patriarchy out of Judaism and to incorporate a deity who can be called "She." With Geller, Weisberg has investigated the rituals and texts of her religious tradition, and has given months to her Torah-inspired masterwork, "The Scroll." A monumental 94 feet long, this work depicts a life's journey blended with biblical story and Jewish history. Weisberg's sources are clearly autobiographical as well as theological; the artist appears with her friends and family throughout "The Scroll." She uses the Torah to illuminate her own life and to link it to that of all Jews, to meld the personal with the universal.

Developing the images for "The Scroll" and for related works has opened new pictorial frontiers for Weisberg. She finds herself in the role of pioneer: "I'm imaging; I'm making visual things that have been written about a lot, but no one has ever drawn," explains Weisberg. "It's not only that Jewish women haven't been able to be artists for very long: Sonia Delaunay is the furthest back you can go for someone who's really an artist, not a craftsperson, and she was born in 1886, my grandmother's generation. Jewish men haven't been artists in the mainstream sense much longer."

Weisberg studied art at the University of Michigan—she was honored as an Outstanding Alumna of that institution in 1987—as well as in Perugia, Italy. Soon after moving to Los Angeles, she began teaching at the University of Southern California, where she is now one of the few women to hold the rank of full professor. "I feel nourished by teaching. I have a great sense of vocation about teaching, but now I have a sense of heightened conflict about time," admits Weisberg. "I want more time in my studio, which may mean less time in the classroom. Time turns out to be far more precious than any other thing. I have a heightened awareness that I might not have all the time in the world. I don't want to waste it."–B.A.B.

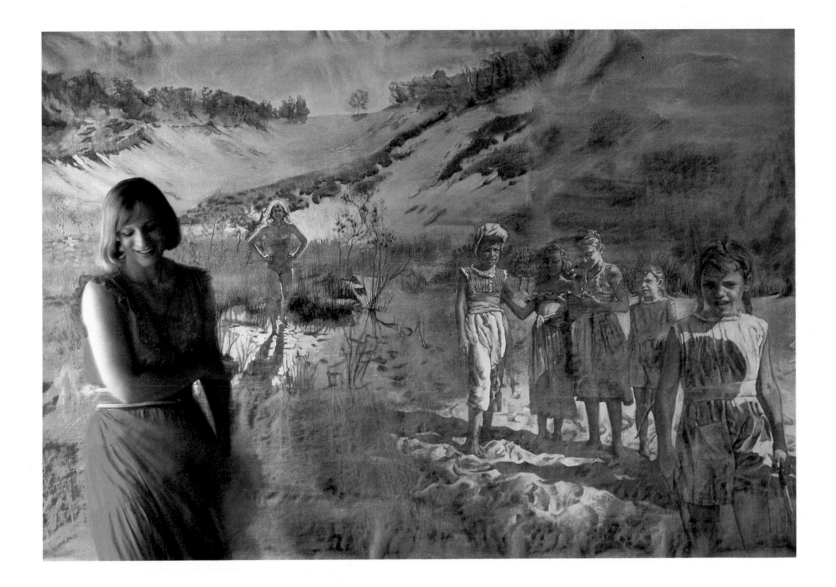

"I look at the world out there—and it's funny, and bizarre, and tragic—and I get myself worked up," says Ida Applebroog. "Then I stomp into my studio." She adds, "Artmaking is like riding naked through the streets—it's the most risk-taking." She grapples with serious social and political topics in her work through paradox, irony, and self-commentary. Applebroog's painted figures are symbols and characters for the artist, and they also bring to mind many of the issues of our day. "I'm concerned about the damage of past wars, the problem of hunger and famine, the neglect and abuse of children, the monstrous quality of a greedy society as reflected in its citizens, the unforeseen disasters of a world explosion."

Some of Applebroog's earliest figures of the 1970s were not painted but drawn, and accompanied by texts on small artist's books she sent to a mailing list. "I decided to make books as a way of finding and communicating with my own audience, without dealing with galleries," she explains. In 1977, Applebroog made 10 books, titled "Galileo Works." Two years later, she sent 11 books called "Dyspepsia Works" to her self-selected direct mail audience, and in 1981, seven "Blue" books. Today, these limited editions are considered classics and prized possessions by most recipients, although, she notes, "At the time, some people demanded that I take them off the mailing list—they hated receiving the books!" For the past several years Applebroog has been mostly painting, and her latest canvases are her most painterly to date. Yet she remains a conceptual artist whose commentary includes linear narratives that can be "read" left to right, and non-linear stories that can be read in all directions.

"Sometimes I see that I've told a private story," Applebroog admits. "I want to cover the picture and keep it from the audience, but I don't. I know that everyone brings to the work his or her own experiences and background and may interpret the piece like a rorschach, in their own way." Art historian Ronald Feldman of the Ronald Feldman Gallery where Applebroog exhibits in New York, tells of meeting "an Ida Horowitz" in 1971. Then, after hearing about the exceptional work of an Ida Applebroog some years later, Feldman met the same artist. During a painful period of psychological metamorphosis, she had renamed herself. In a germinal process of psychic and artistic transformation, Applebroog committed herself and her work to unmasking deception and plainly stating some hard realities by placing human foibles in our own faces.

Women predominate in Applebroog's large and small easel canvases of the last few years. First outlined as schematic notations, female figures have been painted in increasingly fleshier, fuller tones. Applebroog's mature women are ample Sleeping Beauties and Rapunzels, draped in housecoats and bursting corsets. They look as if they have awakened with a start from the mute "depression" that often characterizes older females. Betrayed by age, these women are separated forever from sexy social myths and mothering stereotypes. Unreasonable, they brazenly show their bosoms and pee in public; uncontrollable, they stick out their tongues instead of holding them and sealing their lips. Wild, they bare their teeth and laugh out loud. Applebroog painted a woman standing stark naked before an audience of clothed men. She sticks out her tongue. She is not taunting but acting within the boundaries of her exposed condition. She is being observed like a corpse in a medical theater, a subject depicted by artists from Rembrandt to Thomas Eakins. For such an examination, a blindfold renders the woman-subject even more helpless and anonymous. Everything can be seen. Almost. Thoroughly exposed, the woman braves a further, but active, self-exposure when she opens her mouth and unfurls her tongue.

The magic that transforms pieces of paint stuck to a canvas into an unfolding panorama—the "movement" of paintings—is always social as well as formal in Applebroog's work. When she attaches panel-frames to the sides of larger canvases, she implies the action-in-time of films. In fact, Applebroog's two-dimensional picture composites resemble movie story boards, but without story lines. Applebroog arranges her canvases containing portraits and figure groups of disparate scale, emotional tones and associations to require and at the same time resist synthesis. They recall that fragmentation of life in these times can be compounded and complicated by having to pay split attention to simultaneous, contradictory information and values. A contemporary philosopher held that the responsibility of madness is implicit in passion. But it is precisely in passion that Applebroog has located power. Burning us out of our narcolepsy and amnesia, her work seeks to wake all Sleeping Beauties and Rapunzels, chastised and empowered. –A.R.

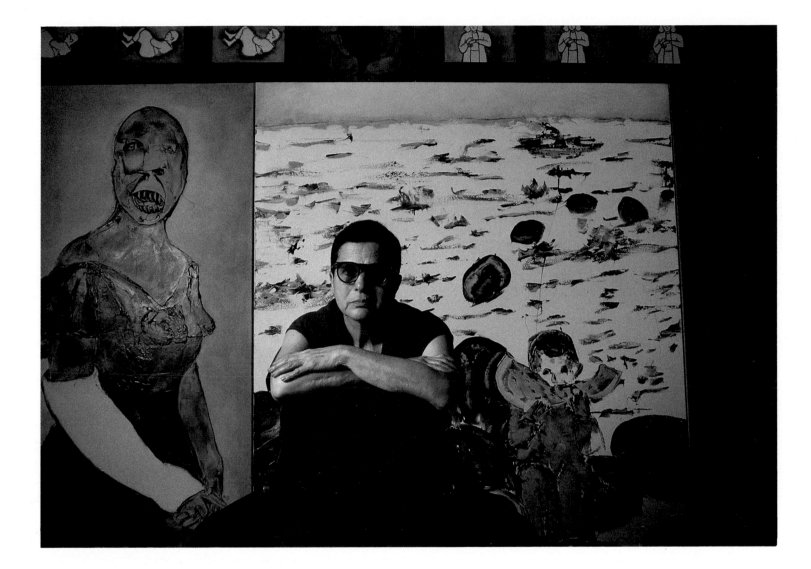

Cheri Gaulke is a performance and video artist whose work ties broad global issues to painfully personal ones. A recurring theme in her work is how she, as a woman and a feminist, can find a place in her Judeo-Christian heritage, and further, how that heritage is linked to what she sees as a technologically dominated world stampeding toward nuclear destruction.

Gaulke was first exposed to performance art in 1974 when she traveled to Scotland to attend the Edinburgh Arts Program directed by Richard Demarco. Demarco led a group of artists through prehistoric spiritual sites then through contemporary galleries in the British Isles. Inspired by the avant-garde performances they were seeing, Gaulke and the other 12 women in the group developed several collaborative performance pieces. Gaulke found her entire attitude toward the visual arts transformed. "I felt so liberated that my own body could be the medium for my art—it felt so comfortable, so empowering."

Gaulke returned to Minneapolis and an art school that had never heard of performance art. As she introduced the new genre to her professors and colleagues, her educational endeavors began. "I loved those early days of performance!" recalls Gaulke. "You could shock people, surprise them. It was so refreshing to have found an art form that could drop people's jaws!" The following year, Gaulke traveled to Los Angeles, intending to stay for only a few months in order to learn from the staff of the Los Angeles Woman's Building how to found such a feminist art organization, and then take her knowledge back to Minneapolis. However, the months stretched into years, and she has resided in Los Angeles ever since.

Collaborative efforts have been a major portion of Gaulke's history. She co-founded the Feminist Art Workers (FAW) in 1976, a group whose purpose was to use the techniques of feminist education and apply them to performance art. In 1981 Gaulke also co-founded a performance group named "Sisters of Survival" (SOS). The SOS was initiated when members of the by-then-dissolved FAW group met with members of the "Waitresses," another performance group, and realized they wanted to develop work that they could tour through Europe. At that time, Gaulke was struck by a "Time" magazine cover photograph that showed a skeletal mask on a European who was protesting the arms race. The SOS realized that as American political artists, they had to address the arms race if they were to travel in Europe. So they developed events about the arms race for the media here, collected American art on the subject, then carried slides of the work throughout Europe. Dressed as nuns in rainbow-hued habits, they produced anti-nuclear performances on sites as diverse as Avebury Standing Stone Circle and Covent Garden. The SOS is still active and Gaulke is currently involved in another collaborative project, an interactive piece with women artists in Mexico. "I have a real collaborative personality; I work well in that structure," notes Gaulke. "Although I usually have a vision of what I want, I'm open to hearing other people's ideas and working it out as a process. Working collaboratively is not only part of who I am personally, but it's part of my politics. It's what I believe in—that people are equal, that everyone has something to contribute."

By 1976, Gaulke also was working on her own individual projects. "I need to work both ways," explains Gaulke. "I need to do my solo work, which is really idiosyncratic, about the things that drive me and make me crazy." Her first series of solo works dealt with the themes of feet and shoes. She developed a strong identification with the Chinese women who had their feet bound, and began to see both bound feet and high heels as metaphors for women who had been cut off from their sexuality. "I think our sexuality is very earth-oriented and we can't really feel that connection with the earth if our feet are lifted up on high heels, if we're off balance," asserts Gaulke."

From 1982 through 1987, Gaulke worked on a performance triad that addressed Christian attitudes about the body and the despisal of the flesh. The pieces dealt with her personal heritage—she is the progeny of four generations of Lutheran ministry—and with her dreams. In "This is My Body" (1982-83), she explored images from the history of Christian art and sought to find her place in them. "Revelations of the Flesh" (1985) dealt with the potential atomic destruction of all flesh and was performed as part of a major series sponsored by the Los Angeles Museum of Contemporary Art and staged in a church rather than at the museum. "Virgin" (1987) addressed not only the term "virgin" and its original significance of independent woman, but also all the myths of miraculous conception and birth, and finally artificial insemination. At the time Gaulke worked on "Virgin," she was considering artificial insemination herself. She combined theatrical presentation with video and slide imagery, parody of television formats, and the unsettling hysteria of a robot or automaton. The mix was poetic, unusual and visually impressive. Throughout her career, Gaulke's choice of the performance medium has allowed her to present material that is autobiographical, metaphoric and challenging. –B.A.B.

Born in the port city of Cartagena, Colombia, but educated in England, Patricia Gonzalez's paintings merge the lush sensuality of the tropics with an elegant intellectual underpinning. Her father was an architect, her mother an architectural student who gave up her professional training when Patricia was born. Gonzalez's parents divorced when she was seven. Her mother found herself, as a single woman with three children, having to conform to certain patterns of behavior that were very restricting at the time in Colombia. She determined to go away for a year, with the intention of showing her children a different world, and then come back, so they traveled to England—and they stayed. Gonzalez's mother taught Spanish, later worked in a clothing store and then developed a career as a watercolor painter and interior decorator. As a result, all of the children were encouraged in their artistic endeavors. "I just did what I thought was normal," remembers Gonzalez. "I drew and painted, it didn't seem special."

Intending to pursue fabric design, Gonzalez entered London's Central School of Art and Design in 1976, but she did not like the fabric design department there. She then pursued painting at the Wimbledon School of Arts and received her degree in 1980. Throughout her education, Gonzalez felt she was being pointed in certain directions. "There was abstract expressionism or conceptual work or performance or naturalism or political work—but none of it quite jelled with me," explains Gonzalez. "Then I saw the films of Satjayit Ray, first his 'Distant Thunder' and then all the films of the 'Epu Trilogy.' Ray used very personal, particular things, yet they were universal. His films worked on many levels: on the emotional level, the poetic level, the political level." Gonzalez adds, "Also, there was Frida Kahlo, a painter whose work I discovered while thumbing through a book in London. Those were the two pivotal people who really made a difference in the direction I took. They pointed toward a place where the personal becomes the universal. It also was important that both Ray and Kahlo were from Third World countries like me."

During the last year of art school, Gonzalez began painting large, bright images about things that happened to her, about her home, people she knew, parties she attended. Her art evolved to what it is today—an integral part of the process of self-knowledge. "I think that's what all art does, hopefully," says Gonzalez. "It's a journey of self-discovery. It's finding out what it is that you're truly interested in, what really moves you, really touches you, so you can focus more on those things. It's just experience, really."

Gonzalez left London in 1980 and returned to Colombia for eight months. She found herself in a totally different environment and did not realize how restrained she felt until she traveled to London for a holiday and then panicked when faced with the necessity of returning to Colombia. She considered moving to Austin, Texas, where her father lived, then decided on Houston, where she joined Derek Boshier, whom she had met at Central School and whom she soon married. Gonzalez began painting in a small spare bedroom in her home. She remembers having to step into the kitchen to get full views of her work. As a result, her first Texas paintings were quite small. After two successful commercial exhibitions, Gonzalez realized she needed larger studio space. Since then, she has moved into a larger studio as her scale increased to the six- to eight-foot range she now works in.

When Gonzalez began painting in Houston, her art addressed that eight-month period in Colombia. She was trying to grapple with the difference between internal and external perceptions of reality. "It seemed this way to me, yet it was really that way. I was exploring the world as I saw it, trying to find a point of reference," explains Gonzalez. "There is a verb that explains it in Spanish: *ubicarse*, to find oneself. I realize that's what I do all the time. I'm constantly redefining how I see the world, trying to reposition myself. I consider myself an expatriate now, so it's not only redefining what I see around me immediately but also how I see myself, my own country and my current position in a different country." While her work from art school and from the first years in Houston were quite autobiographical, Gonzalez's recent work is much less so. "Ultimately, when you're absolutely literal in autobiography, you start excluding as well as including," notes Gonzalez. "There are only so many things people will identify as having something in common with. I'm more interested in the universal level." Yet when asked if the verdant, fecund paintings she did during her 1988 pregnancy had to do with being pregnant, she replies, "It's inevitable. Everything that happens in your life somehow filters through into your work. If you're being honest, it's bound to. That's the essence of creativity: Things flow through you, are transformed, reformed and then come out of you."–B.A.B.

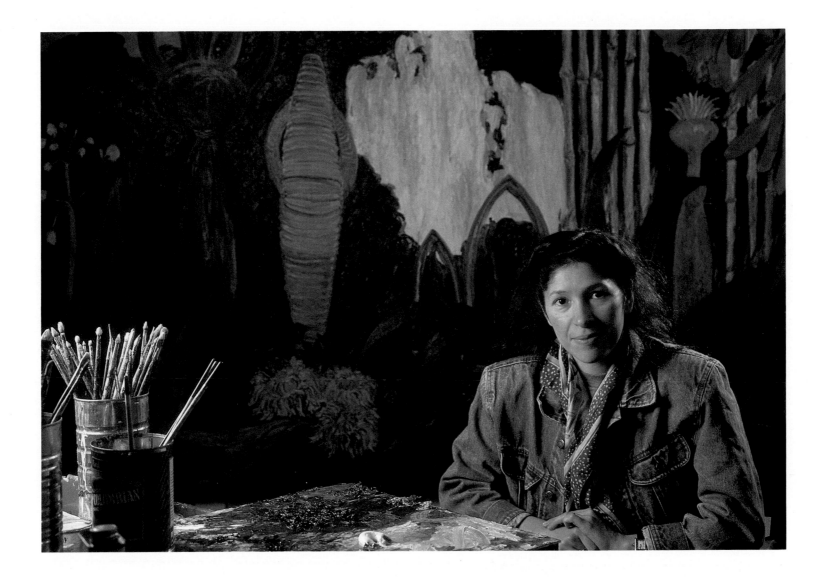

"My work can look like a group show, but that's not problematic for me," notes Cynthia Carlson. "That's not a criticism of my *oeuvre*. My diversity has been a reasonable and appropriate way to respond to the time in which I'm alive and being an artist."

In the fall of 1987, Carlson installed a room floor-to-ceiling with painted relief collages placed in boxes that she had made from her photographs of objects left at the Vietnam Veterans Memorial in Washington, D.C. "Vietnam: Sorry About That," the title of her installation in "War and Memory: In the Aftermath of Vietnam" at the Washington Project for the Arts, was taken from the words on a stitched emblem attached to a military beret found at the memorial. For Carlson, the items tacked onto or placed beside the Wall, collected daily and archived by the National Park Service, "offer testimony not to the noble purpose of war, but to the endless, utter waste and destruction of human lives and the failure of governments to solve differences through any other methods."

Why did Carlson choose these personal, highly charged yet, for the most part, visually unimpressive mementos instead of the monumental black granite wall itself as her vehicle for naming the war waste? "I don't live in the time of masterpieces or of splendor in art, the cultural accumulation of everything wonderful," she explains. "Today the general public places very little value on art as anything more than another commodity. For me, moving against this role means finding ways of working that are impermanent or casual-looking, flamboyant, ironic or humorous."

"Wanting to be an artist," Carlson muses in her Manhattan studio, "is something I always remember, since I was very small." Carlson describes her parents as "blue-collar people who expected me to get married and work in a bakery or something." They didn't encourage her early efforts at drawing and painting. "My being an artist was a rude awakening for them, but, to their credit, they didn't discourage me." Carlson studied at the Chicago Institute of Art, but notes, "Even when I went to art school, I didn't know what a living artist was. I thought that people who made paintings were dead; if you were an artist now, you had to be a commercial artist." But when asked to declare her major interest in school, she chose painting.

A move to New York to attend graduate school at Pratt Institute placed the Midwesterner squarely in the center of national art activity. It would be eight years after graduate school, however, before Carlson would feel that she had found her autonomous presence in art and come into her own. "The first works I knew were good were all 'thick paintings'— abstract, visceral responses to my materials," Carlson recalls. In the early 1970s, she painted pictures that went against the grain of reigning formalism. These pictures were bold and eccentric in color; technically related to Chicago imagistic art and craft in execution. Carlson's grid became a structure on which she could make patterns that were decorative in the extreme. Her colorful, viscous paint contradicted the current implications of its own structure, making a playful contemporary comment on the staid and highly structured modern painting of previous decades, symbolized by her grid.

"The physicality of the paint itself became so much my issue that eventually I had to take that paint off the canvas," Carlson notes. In 1976, she stopped painting individual easel works and embarked on environmental "wallpaper," painting directly on the walls of rooms and alcoves; decorating the exterior sides of buildings. This site-specific work linked her with the "Pattern and Decoration" movement of the 1970s and 80s, which emphasized craft techniques and the idea of adornment. This art movement was strongly influenced by the historical consciousness and pluralistic ideology of feminism. Carlson claims, "My work is a response to the one-dimensionality of a patriarchal ordering. Feminism or pluralism offers a variety of ideas and possibilities simultaneously, and an eclectic way of thinking." However, she adds, "Art in the late 1980s doesn't incorporate that kind of thinking. The market can't withstand too many choices!"

"My new body of work is about angels," explains Carlson. "But I haven't yet found a form for it. I'm not religious or spiritual, I'm primarily a pragmatist. I don't understand my interest in angels, but after 25 years as an artist, I have learned to pay attention to these interests, trust that they are going to lead somewhere, even though I don't understand them."
–A.R.

"I have never really abandoned my childhood goal of missionary work," explains Ruth Ann Anderson, the daughter of a fundamentalist minister and a religious educator. "Only, my guidebook isn't the Bible anymore." In her younger years, Anderson followed in her parents' footsteps and attended Westmont College in Santa Barbara, California, in order to further her ambition of becoming a missionary. She joined the Campus Crusade for Christ, participated in Bible quizzes and went to "secular" campuses to witness about her faith. But gradually, she began to realize she was not comfortable at Westmont. A major issue for Anderson was her middle-class background, which differed considerably from many of the other students who were wealthy. She began to perceive an awkward, distancing class difference.

Eventually, Anderson left to attend California State University at Long Beach, where she found herself drawn to social work. Her career choice led her to question her religion. "Being a social worker and being a Christian are not necessarily compatible," notes Anderson. "Social work has a wider view of the world, it draws from several different disciplines and sees society as the dominant factor in personality. Prior to that, I believed God was the all determining factor." Anderson was involved in social work from 1967 to 1971, then married and "escaped" to the countryside of Northern California, where she and her husband bought a house on an acre of land with fruit trees and a garden. When her daughter Dionne was born, Anderson says she "went through the whole housewife syndrome. I stayed home for two years and I thought there was something wrong with me. I had never been so depressed in my life and I had this cute little girl Living in a hick town with my husband, a social worker, never around, it felt like I had no escape." Anderson wanted to return to work, but her husband was not supportive: "The idea of my working was not part of his agenda. So as a compromise, I convinced him to let me take an art course—and that was it!" That art course was the beginning of her commitment to art and the beginning of the end of her marriage.

Eventually, Anderson returned to California State University at Long Beach to pursue a master's degree in sculpture. She had decided on sculpture after completing a piece that received remarkably high acclaim from her teachers in Northern California. In that piece, she created a series of casts from her body, constructed of hand-made paper. Anderson's sculpture still involves the figure, often employing casts of bodies; however, her focus has become decidedly spiritual. The change in Anderson's work was brought on by a compelling convergence of events. In one year, she experienced a major personal crisis related to an automobile accident and divorced her husband. Shortly after that, she read "The Myths of Avalon," which tells the story of King Arthur through the eyes of his sister Morgan, who was a witch. That was Anderson's first exposure to the concept of the Goddess. "After reading that book, I took a Spring Equinox workshop and I felt like I had come home," recalls Anderson. "It was where I belonged, what I'd been looking for all this time. I felt ecstatic."

Anderson became involved in what she calls the Women's Spirituality Movement, which encompasses many different credos and practices, but the central belief is in the Goddess, a female divinity who is closely related to the earth and to life-giving forces. "When I first started, I saw the word 'goddess' as being a metaphor for nature," explains Anderson. "I think now it's more an understanding of a feminine energy that I would qualify as nurturing and powerful and also terrifying in her destructive aspects—all the elements of the universe in a very powerful feminine entity who has a thousand ways of being manifested. For me, emotionally, she is personified in the moon." As part of her personal search for the Goddess, Anderson has created a series of "Full Moon Rituals." She climbs to the roof of her downtown Los Angeles studio and there, enveloped by the echoing emptiness of nighttime in the industrial area surrounding her, she communes with the milky orb. The art that has emerged from her moon rituals is a series of drawings dominated by central iconic spheres and surrounded by curls, spirals and serpentine interlace. She folds paper scraps, penned with the names of her fears and hopes, into fragile bundles, and attaches them to the drawn surfaces.

Anderson also continues to sculpt. She calls a recent group of sculptures "Menhirs." "Menhirs are stone spirits that act as connectives between universal energy that is free-flowing and earth energy that is contained," explains Anderson. "They can create a sacred space to help me as a person to be quiet enough to cleanse my mind of the garbage that moves around in our society, to really get to the deepest parts of myself that I think are the most universal in nature." Her "Menhirs" are female figures that crouch like stones or fetuses, to merge with the earth. Although sensitive and vulnerable, they are neither passive nor weak. Slowed and settled into their cradles of leaf and rock, they nonetheless emanate power and the tense promise of transforming action. –B.A.B.

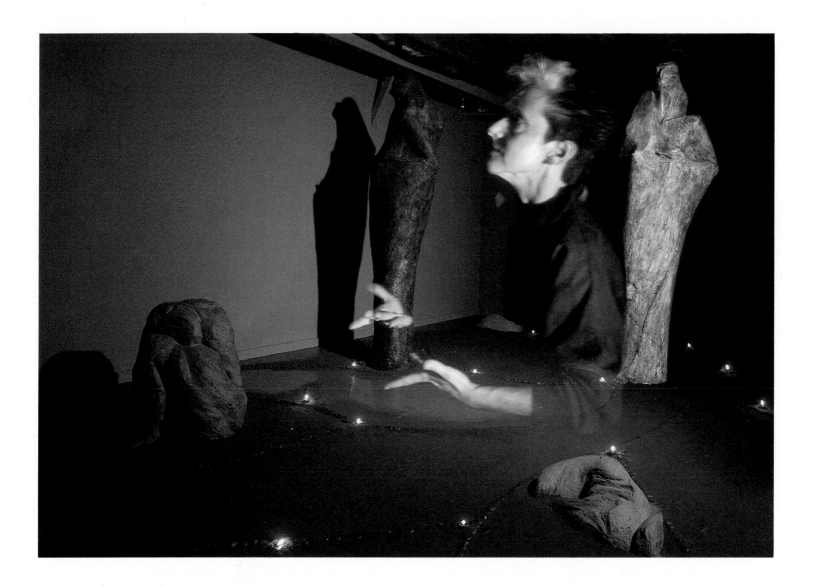

"The male standard has been universal. Images in art are images that men have made," observes Nancy Spero. "The correction is simple—equally a female standard with images in art that women make." In her work, Spero expresses the dual nature of female experience: She balances the celebratory ideal of the Goddess with historical woman as a victim of external circumstances.

Born in Cleveland in 1926, Spero was encouraged to be an artist by a few of her teachers, but, she admits, "I always fought it. It was the late 1940s and I thought that art wasn't serious enough, not knowing how very serious it is! I went off to college in Colorado and took academic courses, but at the end of my freshman year I decided on art and transferred to the Art Institute of Chicago." The Art Institute was an extremely lively place during the late 1940s, recalls Spero, who found her peers to be "the best thing there." She met Leon Golub, a World War II veteran studying art, and they married five years later. After graduation from the Art Institute, Spero went to Paris for a year instead of attending graduate school and while there, she studied painting at the Ecole des Beaux-Arts and the Atelier André L'Hote. Spero returned to Paris in the early 1960s where she lived with her husband and two small children, and while there, Spero had a third child. She produced a series of black paintings of lovers, prostitutes, many-breasted Great Mothers and mothers with children.

When Spero returned to New York in 1964, she explains, "I had a conflict with myself. I had been painting existential themes since 1955, but I became involved in anti-Vietnam War activities and I wanted to respond to the war in my work as well." Spero left oil painting and began to use gouache and ink on paper. Her "War Series," on which she worked from 1966 to 1970, addressed the destruction and devastation of the Vietnam War. Images of angry eroticism and excremental violence, expressing Spero's deepest understanding of the impulses that create war— provoked by media accounts from Vietnam—became a part of her work. She was also strongly affected by the works of French writer, Antonin Artaud, which exemplified for Spero the artist's suffering, both mental and physical, in a bourgeois society. "Artaud's work allowed me to make a connection between a political and artistic alienation," explains Spero. In his writings, Artaud had complained about losing his tongue and therefore not being able to speak. Spero, identifying Artaud's silence with her sense of being silenced by the art world, used protruding tongues in her "Codex Artaud" paintings (1971-72). "They are defiant and phallic, by 'sticking out one's tongue,' a gesture of social subversion," explains Spero.

Spero again addressed violence, this time violence against women, in her 1974 work on paper, "Torture in Chile," in which she began using female images exclusively to represent both men and women. "There are many more male political prisoners than female, but I decided in addressing the problem of torture, to emphasize only women," explains Spero. "Both men and women are sexually abused, but for women sexual assault is always central to attacks upon the body. Woman has had the status of victim 'par excellence' from time immemorial." She adds, "Women's issues are as profound and varied, as thoroughly political as anything else." "Torture of Women," created from 1974 to 76, was Spero's first feminist work. "I consciously addressed the question of the status of women from the perspective of torture victims," explains Spero, "the worst possible circumstances in which any woman might find herself." During this period, Spero was a member of New York's Women Artists in Revolution (WAR), the Ad Hoc Committee of Women Artists, and was one of the founding members of A.I.R. Gallery, a women's cooperative gallery when it opened in 1972.

Now Spero uses a hand printing process, printing and then reprinting the same female image, a repetition of the image to denote a continuous presence. "I apply pressure to the plate or reduce the amount of ink for variation," explains Spero. Some images are almost transparent. Overlays create what Spero describes as "an impression of a carnivalesque movement"—frenetically dancing figures that Spero uses to represent an increased tempo in the actions of women in history. To construct a history that is simultaneous rather than simply linear, Spero places images associated with divergent historical periods, such as the goddess Artemis alongside a contemporary female Olympic athlete. "The past reverberating to the present," states Spero. "Only recently has women's history been uncovered. I'm recovering the past through all kinds of images by women, from goddesses to victims. An artist has power, if she has a voice that can enter the public discourse."–A.R.

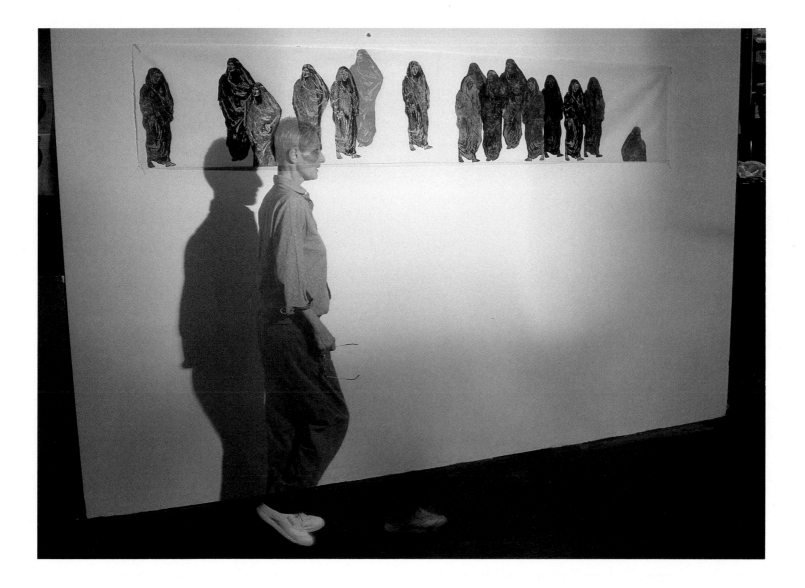

"I have been a closet artist my whole life," admits Nancy Chunn, who would paint and draw on small papers, then secret them away. "I never believed I was an artist. That was my struggle." Chunn's artwork was completely private until 1976, when she had her first show at the Cannis Gallery at the Los Angeles Woman's Building. The small watercolors she exhibited were made with the help of her husband at that time, Tom Radloff. They played a game: "He gave me objects. I made compositions and painted them." Shortly after her exhibition, Chunn moved to New York to pursue her art.

In 1979, when Chunn was faced with the loss of her father, dog and cat, she was moved to create a series of powerful works on death and dying. They led to Chunn's "Predator Series" in 1982. "I had a flash," she remembers, "of the idea to combine animals and parts of human bodies." At first, her "Predator Series" paired a fish eagle going after a shoulder, or a dingo with a skull on its head. Then, when combing a used bookstore for pictures of animals, she came across an old atlas. "I was struck by the shape of the countries," notes Chunn. "I saw a way to continue the 'Predator Series' by painting continents in colors similar to map books with a stippled technique I'd used for the animal paintings." Chunn also combined images of continents with those of farm machinery as a way to explore her questions: "Are things being constructed or deconstructed? Created or destroyed?" Chunn explains, "I wanted to show the beginnings and ends. I worked on the backgrounds more and more. I wanted to emphasize the importance of background, context. When I first made paintings about death in the late 1970s and early 1980s, I realized that my mother, who had died in 1971, was the background, the potential, the history in that series. Now I paint the backgrounds as the female element of each work."

In the early 1970s, Chunn was working as an assistant to the dean at the California Institute of the Arts (Cal Arts), School of Art in order to support herself while she followed her visions as an artist. A native Californian, Chunn already had graduated from Cal Arts. Perhaps her prolonged association with that dynamic school and its emphasis on conceptual art, allowed Chunn to fully absorb its avant-garde lessons and also to transform them. Chunn has integrated the conceptual *and* political in her paintings, charting the physical and social features of Vietnam, Chile, Nicaragua, Guatamala and Iran by making elegant hand-colored maps of each country.

Chunn's work bespeaks her passionate concern for ending societal oppression and physical destruction. At the same time, her paintings are succinct expressions of a hard-won synthesis of her formal means. The tensions produced by the complexity of social and aesthetic elements within each canvas created an even compression, a quiet urgency to consider the state of affairs of Chunn's subjects and the feelings put forth in her work about them. "My continents became individual countries, and I began to paint them like meat—the kill for more powerful predators. I painted Cambodia like strips of bacon, El Salvador like liver. I'd go to the butcher and buy various meats to paint from, although I never ate them."

Chunn's subject matter is straightforward. But representations are not embellished lessons; the shapes of endangered countries and chain links are representative emblems, vehicles to move the viewer through the dark rich flatness of her paint to the analogies and relationships suggested by the continents and their confines. "I'm enveloped by my work," Chunn states, keenly apprehending the human condition today. She likens herself to the people whose geographical limits she has portrayed, both imprisoned by her material and historical circumstances and defiant even in the face of the hopeless immovability of some of these circumstances.

A decade ago in a dream, Chunn asked to use all of herself in her art. Recalling the dream, she explains that a voice told her, "Yes, but you have to make it better." Chunn makes every painting better by working it thoroughly, then doing it over and over again. Through this process, an image of Chile, Vietnam or Iran, repeated in several versions in her current body of work to study the possibilities of paint and get closer to what she wants to express, becomes a context for her ethical and moral feeling and aesthetic meaning. Chunn embraces the feminist imperative voiced by poet Adrienne Rich to "study our lives." "I read extensively about the lands and situations I re-create," says Chunn "and I feel a personal identification with people and their plights. I want to do something strong; paintings that tell about myself and the world."–*A.R.*

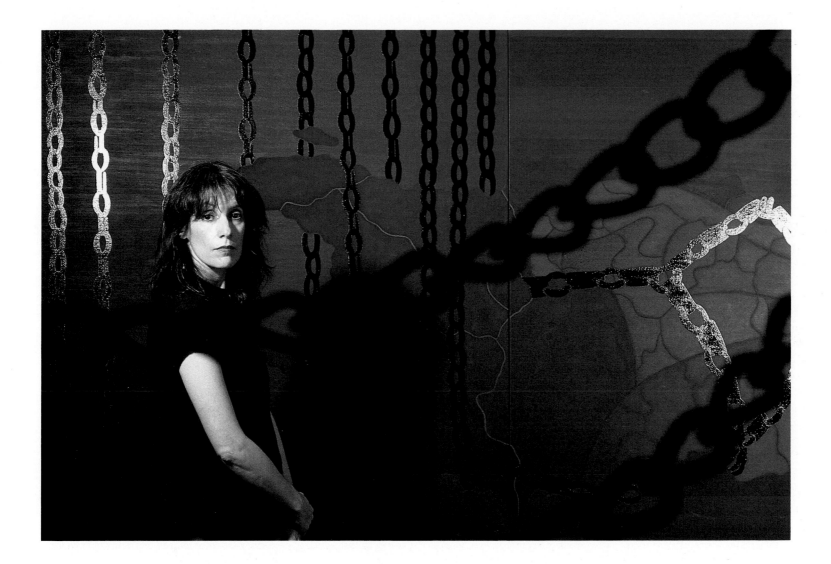

Susanna Coffey knows that we are taught to see, that each society constructs the parameters of its vision. Especially intrigued by the pictorial vocabulary Euro-American culture has built for the representation of the female form, she explores the possibility of painting women in a new, unbound fashion. "Quite early on, it was clear to me that the 'visual language,' that is, the way we decide what things look like, was a language developed by men. I simply wanted to be a woman painting women in an open-ended way. I believe it is how a figure is constructed that gives it its primary meaning. So the paintings I make are not about portraits—not even necessarily about looking at a figure—but about the codification that exists when one presents a picture or a sculpture of a figure."

The subject matter in all but her self-portraits is taken from the myth of the goddess Demeter as recorded in the Homeric Hymns. "Probably because they were originally spoken, the images in Homer are so visual, they call to me to be fleshed out, clothed in paint," says Coffey. One of her large canvases depicts the time when Demeter had grown angry after a long search for her absent daughter, Persephone. Demeter continued her search at midday, carrying two flaming torches, scorching the earth as she passed, igniting the land and sky with a hot, yellow light. Coffey depicts the goddess' invincible walk rather than her figure. The striding form seems to burn through the lush, swirling landscape. The paint is thick, rich, hallucinogenic. Because the artist focuses on the goddess' action, not her body, the viewer cannot visually consume the incandescent Demeter, but can only admire her strength.

Throughout her career, Coffey has used herself as a model; some of her most compelling works are self-portraits. "It's problematic. It's so hard to get beyond an ambivalence toward my woman's body," admits Coffey. "In the self-portraits, it's less of a problem. There's no body there, just a head. Also, they're about a simple moment, a simple construct. I'm safe there. The moment of looking offers the closest I can get to a non-consensus view of what that could be. I work very directly and am absolutely truthful." She adds, "I make no attempt to express myself, or to make my self-portraits more artful or less artful. I simply paint what I see. I do them out of curiosity to see what I look like in the purest possible way. There's emphasis on that word 'possible,' because how we see ourselves is really the history of images, which has not been made by women.

"People tell me the self-portraits look androgynous, but how do we know what a woman looks like?" asks Coffey. "Our history of images of women are largely made by men. So my self-portraits may very well be what a woman really looks like. People also say to me, 'You don't look like that. You're much prettier.' What does that mean? Beauty is not only in the eye of the beholder, but totally within the forms history has provided. I don't pretend to be able to challenge that, but these self-portraits are a chance to side-step it."

Coffey has not always had the kind of confidence manifest in such powerful work. Although she won a ballet scholarship at four years old, by the time she reached adolescence, she had developed such a profound ambivalence about her body that she quit dancing. She attended college, but dropped out. She says she married in order "to give myself a place, an identity in the world." Coffey found herself supporting her musician husband by waitressing and doing other odd jobs. Then, in the early 1970s, she got a job as a model in an art school which, she says, put her "back on track." She observed the art students, listened to the professors, and decided, "I can do this; I have something to say about all this!" But she had little faith in her ability to get into art school, and no knowledge of what it was to be an art student. "It was like a foreign country for me," admits Coffey. Ultimately, what gave her the momentum for returning to school was the Women's Movement. "I had no way to visualize anything without a mirror and the movement gave me a mirror," Coffey explains. Coffey graduated from college with honors in 1977 and went on to Yale, where she received a master's degree in painting in 1982. Now she teaches painting at the Art Institute of Chicago.

Two key events lead Coffey through her education to the kind of art she now makes. The first was a class on African art history. While looking at West African wood carvings, she began to realize that "the language of the construction of a figure is its meaning." The second event that deeply affected Coffey was her mother's death from cancer in 1977. "It changed my relationship with the world," says Coffey. "It's as if there is an ocean and when your mother is alive, she's between you and the ocean, kind of like a sea wall. After she dies, you're there, you're the sea wall." Coffey began painting about her mother, about death, about being suspended between the living and the dead. She had to find a way to deal with all the pain pictorially. "It's what I painted about. I didn't choose to—the paintings just came out," explains Coffey. "The parade of images was waiting for me. That's really when I became a painter."–B.A.B.

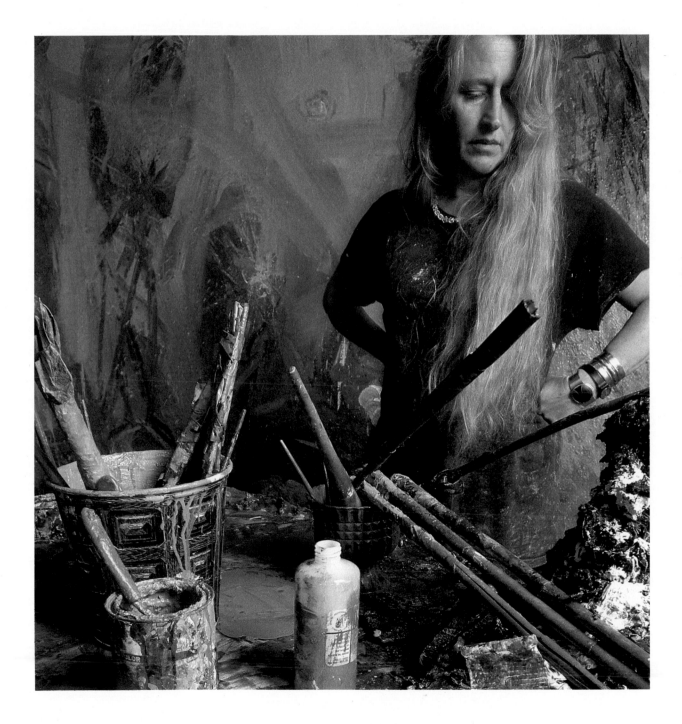

A vision of Jesus in a dream ultimately led Dee Wolff to painting. Although no one else in her devoutly Catholic family is or ever has been an artist, Wolff clearly remembers announcing as a small child that she was going to be a great artist some day. She received little encouragement for her talent, so when she traveled to Texas to be near her future husband and attend the University of Houston, Wolff studied creative writing rather than art. After graduating in 1971, she took a job as an assistant manager of a local hotel. Throughout that year, Wolff had a series of dreams. "I was in the catacombs in Rome and a man with a torch was leading me," she remembers. "We were winding into the darkness and then we came to this room. There was a Christ figure sitting on a big stone tablet. He looked at me and said, 'It's time for you to begin painting.' I had that dream about 10 times before I finally listened."

At the time Wolff entered art school, she also came across a copy of Carl Jung's "Man and His Symbols," which affected her profoundly. "The book blasted me out of whoever I used to be into my new person," recalls Wolff. She took classes at the C. G. Jung Institute for more than 10 years. It was through her Jungian research that developed what she considers a universal interpretation of her dream: "It was a stereotypical Jesus from holy cards; He was radiating light. I realize He represented my animus telling me that this creative urge had to be given its freedom."

Wolff's work uses what might initially be considered traditional Christian imagery to make what she hopes are more all-embracing statements. Doves, surrounded by spiky lines of golden light, dive earthward. Figures are nailed to crosses; sometimes the crosses are huge and so many figures are on them, that it seems all of humanity is being crucified. Halos flame, bushes burn, the very earth is seared by potent spiritual presence. Wolff's paintings range from miniatures on tiny hand-made paper sheets, which resemble medieval manuscript pages, to large wall-sized canvases that engulf the viewer in a surging, apocalyptic space. Whenever Wolff uses color, it is vivid and luminous, combining fiery orange and deep, sapphire blue. She also does pen drawings of thin spidery black lines on white paper. But no matter what the scale or medium, there is a marked intensity in Wolff's work that would be termed religious if the artist herself hadn't made such a determined and arduous journey away from established religion to more cosmic relevance.

The journey began in her youth. Wolff remembers spending a lot of time in the countryside. "Out in nature, watching the light change in the trees, I would have these feelings that there was something so much present, so beautiful there," recalls Wolff. "Then I would go to my religious education classes where they would tell me all this stuff which was not true for me. I would always ask questions. At one point I went around asking people, 'Who is God?'" Wolff still asks that question. In search of an answer, she has not only studied the rather secular dictates of Jung, but also the process of Vipassana Buddhism, a form of Buddhist meditation that leads to the clarification of consciousness. Wolff explains that her meditation and art are combined today: "When I'm working, painting becomes that meditative act." The harvest of Wolff's spiritual search is evident in her work. "At this point in my life I feel I've studied so many things and let go of so much that whatever happens in my paintings will be a product of all that I am. The images just come out." The diverse avenues of her journey are evident in the objects with which Wolff surrounds herself. She hangs a William James quote in her studio: "Limitation is nonbeing and God is being itself." Next to it is a photograph of an elegant Japanese Bodhisattva. Above the photograph is her first series of the Stations of the Cross, a group of abstract paintings. She has created numerous series of the Stations of the Cross (the events between Jesus' condemnation to death and his entombment), and is certain that her life's mission has to do with portraying the Stations in contemporary terms. "My ongoing work has to do with finding a way to look at the Stations of the Cross, to give them a language I can understand," states Wolff. "The part of Catholicism that still speaks to me is the ritual."

Although Wolff no longer practices the Catholicism of her parents, she is compelled to use her art to find images for the archetypes she recognizes in Catholicism's ritual patterns. "The Catholic part of me, a very elemental part, is trying to find the meaning of all that for myself," she notes. She uses the skeletons that are so frequently present in Catholic folk art, but with metaphorical rather than literal intentions. "I use death and death imagery as symbols for life, for the psychic letting go of this moment, this time, this experience," explains Wolff. "It's related to the Zen Buddhist concept of Skhikan Taza: to live each moment of your life as if it were the last. I see each of my paintings as an instant, a recollection, a recognition, a letting go, a death, an insight."–B.A.B.

United States industry—from transportation to national defense—and its effect on natural resources worldwide would occupy Jere Van Syoc from her childhood on. "All I heard as a child from my Detroit family was industrial might, warfare and of course, automobiles," recalls Van Syoc. "My sculptures, 'Death-Toys,' are collective archetypes I have rocked and rolled out of my imagination. I bring to these burned, fractured, armored sculptures-on-wheels my enduring fascination with loss, decay, pain, darkness and mystery. This work shows my empathy with nature which has been poisoned by the modern world."

Recalling her childhood, Van Syoc explains, "When I was five years old, my grandfather dropped dead while working on the Ford Motor assembly line, and two years later my mother married her boss, an engineer who made bullet machines for the war effort." Van Syoc was an artist from childhood, encouraged only by her mother, but when her mother died of cervical cancer at age 40, Van Syoc and her 15-year-old sister grew up quickly. "I found solace in art projects," recalls Van Syoc. "They were always produced with the materials I had at hand—scraps of cardboard and paint from the dime store." She constructed works that she could wear or use, costumes that enabled Van Syoc to become whatever she could imagine—"a bull, a robot, 'delirium tremens,' even 'modern art.'"

When 19 years old, Van Syoc bought an old motorcycle, painted it pink and rode it through the streets of Detroit during a couple of rebellious years. By 1955, she explains, "I was so lonely that I was able to conform enough to have steady boyfriends and work for the telephone company as a service representative. I joined the Baptist church and became a Sunday school teacher." Van Syoc moved to Chicago to attend the Moody Bible Institute to become a missionary; however, after only a few months, she experienced a crisis in her religious faith. "I was beginning to feel the spirit of the 1960s in Chicago and the exhilaration of being on my own," she states. "I dropped out of Moody and the Baptist church and never went back." Van Syoc enrolled at the Art Institute of Chicago and her paintings from this period contain an energized central figure imbedded in scar tissue and debris, reflecting the shards of her past personal tragedies as well as her rebirth.

After graduation from the Art Institute, Van Syoc taught high school for several years, but found it completely exhausting. In 1969, she returned to the Art Institute for a master's degree. When Van Syoc began producing art again, she found that her personal concerns had seeped into her work. She made a series of paintings representing her surgeries from a complete hysterectomy, and a group of ashen sculptures related to her grandmother's colon cancer. Her work was misunderstood at school and sometimes viewed as "decorative and feminine." But Van Syoc struggled to make and embellish her objects so that they could serve as an authentic celebratory rite for the dead. A fire destroyed Van Syoc's apartment and studio the following year. "I lost all of my work, tools, photographs, everything," she recalls, "and a few weeks later my grandmother died in a nursing home near Chicago." Van Syoc constructed altars and ceremonial objects that represented the fire, and performed her first art ritual. Later, while a teacher at Nazareth College in Kalamazoo, Michigan, she made a monumental movable altarpiece complete with sound equipment and a bin of plants, and mounted her grandmother's ashes into the guts of the altar. This compelling altarpiece, shown widely in college communities around southern Michigan, later had a place of honor in the living room of Van Syoc's Grand Rapids home, where women's gatherings and celebrations were frequent.

In 1982, Van Syoc moved to Los Angeles to pursue her art. Since then, she has produced a body of found-object sculptures on wheels she calls "Death-Toys." Her sculptures represent what she describes as strange, mutant survivors of a nuclear holocaust and "the awful, dirty, crawly, frightening secrets that we deny and thus that haunt our unconscious." Van Syoc's sculptures have been exhibited in galleries. However, she explains, "About three years ago I got the idea to buy a van and take my work to various places around town and have my own shows—because of the very nature of the work itself. It is of the street and of the automobile." Van Syoc has named these spontaneous gatherings of people with her sculptures "prayer meetings." She hands observers a "prayer card" that says, "Please join me in a collective prayer of appreciation to all terrified human creatures who have brought consciousness this far . . . to accept our own dark and wounded sides" "The Toys are examples of ritualized acknowledgements of the dark, the feminine, the Dionysian side of consciousness, the individual and collective denial of which has made our poisonous age what it is," explains Van Syoc, "yet into this mess the Goddess is reborn."–A.R.

Through a style of painting termed "photorealism" or "superrealism," D.J. Hall creates portraits that depict much more than the human eye can capture in a fleeting glance. Hall heightens the sense of detail and surface in her portraits to effect a sense of permanency. She uses paint to create lasting images of companionable pleasure and leisure. Her work is a desperate attempt to stop aging, forestall pain and decay, and reach beyond the inexorable march of time to immortality.

Hall's childhood experiences were crucial in shaping her art. She was an only child raised by a single mother in a rural area of Southern California. "By the age of seven, and then for many, many years after, I would draw imaginary families with lots of sisters and brothers—never any parents but lots of sisters and brothers, and sets of twins," recalls Hall. "I used art to create the family I didn't have. My whole body of work, and I know it very sincerely now, goes back to creating that imaginary family." Hall has gained great insight into her childhood traumas by working with a therapist. "I have begun to touch things I thought I had buried forever," she admits. "My father left when I was three and my mother had such tremendous emotional problems that she treated me as an adult instead of a child—I guess I didn't even have a childhood. My adolescence was even lonelier because my mother's problems grew worse. Things were so crazy in the home that it gave me an extra sense of isolation."

Art, particularly drawing, has always been an important presence in Hall's life. "I constantly drew people from magazines, especially fashion magazines. That was a real grounding for me; it helped me develop eye-hand coordination." Hall adds, "When I was 10, I decided I wanted to become an architect, and I began spending a lot of time drawing houses and floor plans. I know now that I was trying to make my own space with those make-believe building plans—I wanted to do that desperately. When I went to the University of Southern California (USC), my advisors discouraged me from pursuing architecture. Now I realize they discouraged me because I'm a woman. At the time, I didn't know that and my mother didn't know that. We were as naive as could be." Hall was not particularly aware of feminist issues until she left USC. When she submitted her first artwork to a juried exhibition, she chose to use her initials D.J. rather than her first name, Debbie, so that the jurors wouldn't know whether she was male or female. She remains convinced that the initials have helped her more than once.

Hall enrolled in fine arts instead of architecture at USC and became interested in realism through a photography class. "That was where I finally did something that was satisfying to me conceptually—portraying people and making social commentary," says Hall. "In my painting classes, it was all minimalism, formalist abstraction." This approach to teaching art was used by many professors in the 1960s who were concerned with "art for art's sake" rather than art that addressed social or political issues. Hall's social commentary was particularly biting in her early paintings. She portrayed the wealthy elderly at leisure—often at resorts, lying on beaches, relaxing in pools—with a painfully harsh eye. Their wrinkles were exaggerated, their jewelry ludicrous, their bodies ravaged by time and indolence. Looking back, Hall realizes that during her early 20s she was simply questioning "everything in the world, especially people who meant material well-being."

In 1980, a portrait commission led Hall to photograph and paint younger people. It also dawned on her, at that time, that she should step back occasionally and check what was happening to the detail while she was painting. Previously, she had worked "with my eyes five inches from the canvas, never viewing it from any distance. That's why the wrinkles and other imperfections became obsessive, microscopic and exaggerated," explains Hall. She decided to abandon her use of the telephoto lens because of the way it distorts. Her images became less harsh, less critical. Now there is a softening in her work and the people are treated directly, but with affection.

Hall often lets her pictorial ideas evolve for several months. Then, as she decides how to create her imaginary world, she figures out how to photograph it. She does one or more photographic sessions, develops sketches with collage fragments from numerous photographs, then projects the combined images onto her canvas and begins with a loose underpainting. The most arduous and time-consuming part of her work is the perfectionist surface of her canvases. "I am a compulsive perfectionist," admits Hall. "Ever since I was a kid, I tried to be the *best* in everything . . . which I was, superficially. With art, too, I want to be the very best, which means it has to look perfect, or even better than perfect. I realize more and more that perfection is an impossible thing, but that's what I've been after." Halls' perfectionist impulses are directly related to her desire to freeze time. "I used to think that there was magic, that you could freeze time. I *am* freezing time in these paintings. They will live on."–B.A.B.

"My goal in doing my work is to tell the truth as I see it, no matter how painful or difficult that truth might be," states Judy Chicago. "To tell the truth in such a way that other people might see it and be transformed by it." Chicago didn't speak until she was two and a half years old. Now, almost half a century later, she is a leading spokeswoman for feminism in the arts.

Chicago is best known for her two large collaborative artworks, "The Dinner Party" (first shown in 1979) and "The Birth Project" (first shown in 1983). She is also noted for her role as a founder of the Feminist Art Program at California Institute of the Arts (Cal Arts) in Valencia in 1971 and The Woman's Building (1973) in Los Angeles. "The Dinner Party" and "The Birth Project" both address basic women's issues, and both treat the vagina as a metaphysical issue and symbol of female power. Chicago made it her mission to create such images because she perceives them as visual equivalents of women's nature and experience, which could be universal if they could become visible. "When we look at the Empire State Building or the Washington Monument, nobody yells 'Penis'!" observes Chicago. "We are used to seeing the world through male images, not our own likenesses."

Even her name, "Judy Chicago," has a special meaning for her as a woman and artist. Born Judy Cohen in Chicago in 1939, she chose her own new name in 1970, when she exhibited her work at California State University, Fullerton. In her exhibition announcement, she declared that her act of self-naming was a statement of divestiture from all names given her by men. Chicago was a "red diaper" baby, the child of Communist parents, during the McCarthy era. Her father was a union organizer who died when Chicago was 13 years old. Inspired by the activism of her parents, she struggled against limitations early on in her own education and career. As a young Los Angeles artist during the 60s, Chicago defended herself against what she considered second-rate female status by smoking cigars and painting car hoods to emulate male role models and peers. "I hated cigars, they made me sick," admits Chicago, "but anything for art! After some years in the art world trying to pretend I wasn't a woman, I decided for better or worse I had to be who I was."

Chicago first defined her hard-edged, but soft-colored abstract art as containing "central core imagery"—the design for artwork based on the center of the composition which was, in turn, based metaphorically on female biology in general and the vagina in particular in the early 1970s. "I identify with the surface of the canvas. It's like my own body," Chicago notes. "Virginia Woolf says that art starts from truth to the body. I paint from the center of the canvas, of my ideas, and of my existence. The center is a common impulse in the way women organize space. This should be recognized so that young women can be helped to organized their imagery so that they can build on who they are instead of who they're not."

Chicago's range of perceptions have taken a variety of forms, from the china painting of "The Dinner Party" to the needlework of "The Birth Project," and back to acrylic and oil painting on canvas. Her realizations have led her to change her subjects as well. "By 1982, I couldn't make images of women anymore," admits Chicago. "I have become concerned with participating in a dialogue about the nature of reality and the world we live in. First it involved looking at men, then at the globe." Chicago first exhibited her male images in the "Powerplay" series of paintings at the ACA Galleries in New York in 1986; a series that explores the destructiveness and the despair of men. Her current project concerns the Holocaust. "I believe that the conquest of nature, control of the environment, the rise of patriarchal religion, Vetruvian man as a measure, the development of the scientific and medical minds, the industrial revolution, the burning of witches, are all part of the institutionalization of patriarchal culture. The systematic burning of Jews in the Holocaust is part of the outcome of this historical situation. You can't understand the Holocaust except from a feminist perspective. Without a feminist perspective, the consequences of patriarchy will mystify you."

For Chicago, there is a large discrepancy between her achievement in the art world and the acknowledgement she has received. " 'The Dinner Party' was propelled by audience reaction around the world despite institutional resistance," states Chicago. "But its effect remains invisible in the art world." Still, Chicago continues. "I have no choice. An artist is all I ever wanted to be. For me, making art is the most significant human activity and the most meaningful way to spend my life."–A.R.

In 1983, the owners of Metrospace Art Gallery in Long Beach, California, realized they would have to close their doors within 30 days. As a celebratory finale, they asked 30 artists to do one-day installations in the soon-to-be abandoned space. One of the artists was painter-printmaker-sculptor Linda Vallejo. "I decided to erect a Tree of Life, " Vallejo recalls. "I took this huge tree limb, installed it in a bucket and invited everyone I knew to help me decorate it. Some people sent things in the mail, while many of my friends came to Metrospace, bringing all kinds of objects for the tree. People came in from the street, taking things from their pockets or purses. By the end of the day, more than 20 people ended up sitting on the floor around the tree. Everybody wanted to linger." Vallejo took the tree back to her studio and, weeks later, felt compelled to personalize the experience. She constructed a mask from handmade paper and placed it at the juncture of the largest branches. Then she glued feathers all over it, transforming the top twigs into an elegant headdress.

The Metrospace Gallery installation experience inspired Vallejo to do a series of "Tree of Life" sculptures. "I see the Tree of Life cross-culturally," she explains. "There are many Meso-American examples, but it's also in many other cultures and writings, such as the Bible and the images in Balinese shadow puppetry. As I worked on the series, I began to see the tree everywhere: in photographs of the placenta, coral, lightning, river beds, roots, even in diagrams of the electrical impulses in the brain. After the event at Metrospace, people started giving me trees," recalls Vallejo. "I had been doing assemblage for years, so I began to treat the trees like 'found objects.' Actually I tried to quit making my 'Tree People' at one point, but friends kept bringing me trees!" To this day, one corner of her downtown Los Angeles studio is piled high with trees—with sinuous limbs, gnarled bark, thick blocks of sawed trunks.

Vallejo's incorporation of trees into her art satisfies her profound ecological and spiritual commitments. "I have a strong desire to connect my art with what I believe," she explains. "As a Chicana, I see nature as a source of inspiration. I strive to incorporate the cultural concepts of the Chicano/Mexicano aesthetic in relation to nature, taking a more complete look at the earth and all its living creatures." Vallejo recognizes that being Chicana means being heir to a complex Native American heritage. She studies Native American ceremonial and traditional customs, and is a participant in sweat ceremonies. Although she honors a commitment to privacy about lodge activities, she does speak of intriguing parallels between her art and spiritual search. "The sweat ceremony is like an art-making space," explains Vallejo. "To make art, you have to be open, giving, honest with yourself. You get that same feeling in a good sweat ceremony. The feeling spreads out from your heart. You can open up and say whatever you want with total confidence and trust." Vallejo is quick to clarify that art is not her religion, yet she notes, "In indigenous traditions, if you receive a vision—one of those spectacular moments of understanding—you have to share it with others through music, dance, poetry or art in order for it to work its wonder."

Each year, Vallejo creates a series of artworks for the Days of the Dead celebrations of the Chicano community of Los Angeles. The Days of the Dead is the Mexican version of All Saints Day and All Souls Day observed on November 1 and 2. Families remember their beloved deceased by building household altars in their honor, then visiting and adorning their graves in the cemetery. Vallejo constructs elaborate, velvet-lined boxes in which plastic skeletons dance over fields of rose thorns. In one box, the Aztec Lord of the Underworld, Mictlantecuhtli, hovers in a midnight sky over a landscape strewn with Day-Glow bones. Looking at the numerous boxes she created for the 1988 Days of the Dead, she exclaims, "I make art like some people make cookies. I'm always compulsively busy. I know that I can't quit."

Vallejo, who received a master of fine arts in printmaking from California State University, Long Beach, worked on her series of sculptures using tree fragments as armatures for ten years. During this time, she began to visualize the environments in which the wood figures would live. The environments took the shape of sculpted landscapes created on canvas, with diverse materials building up the dense surfaces on which she attached the trees. She uses gauze, gravel and glue to build up white bas-reliefs, then applies intense color over the surface. "I use a glorious pure palette to recall the Meso-American color spectrum, coupled with the dramatic lighting and image of artists such as Goya and El Greco to bring to life my Latina experience," explains Vallejo. "I strive to maintain the primal attitude of the painting medium, calling on bold and seemingly uncontrolled strokes of color. Now, I can see the entire landscape with fire, earth, water and air." She adds, "I wish to share the beauty of nature to help us remember that it is our source and inspiration."–B.A.B.

Florence Pierce still remembers the first winter she spent in Taos, New Mexico. She arrived just after a blizzard and found the desert, the mountains, the pueblos, the pines, all shrouded in glistening snow. "It was all white, I could smell the white up there," recalls Pierce. "It made the hairs in my nose just crackle!" That winter of 1937 changed her life.

Pierce first traveled to Taos the previous summer to continue studying painting after completing a year at the Phillips Collection Museum School in her native Washington, D.C. "I returned to Taos the next January," remembers Pierce, "fully prepared to paint aspen trees, Indians, Southwest landscapes . . . but nothing doing!" In the few months between her first summer classes and that cold, fateful winter, her Taos teacher, Emil Bisttram, had a spiritual conversion and he had found abstract art in the process. The artists Bisttram gathered around him in the years 1938 to 1941 formed the core of the Transcendental Painting Group. The group absorbed diverse influences: The artwork of Russian Wassily Kandinsky, whose book "Concerning the Spiritual in Art" introduced abstract art and its spiritual aspirations to Europe; the writings of Claude Bragdon, Ralph Waldo Emerson, Frederich Nietzsche, Carl Jung; Zen Buddhism; theosophy and associated mystical schools. The Transcendental Painting Group experimented with vegetarianism, meditation, celibacy and spiritualism. The artists exhibited together, delivered manifestos and published brochures.

Pierce's paintings of that period are large, colorful abstractions with surfaces mottled by textured brush strokes. She married another member of the group, Horace Towner Pierce, whose paintings are darker and more turbulent than hers. Ultimately, Horace began to turn from easel painting to plans for an abstract film. The young couple left Taos for New York City and later Los Angeles to seek funding for his abstract film, but they were unsuccessful in acquiring production monies. They returned to New Mexico, opened a textile printing company in Santa Fe, and developed fabric designs based on New Mexican Indian art. That business ultimately failed, so Horace found secure employment as a technical illustrator with the U.S Army Corps of Engineers, until his death in March 1958.

Throughout her peripatetic marriage, Pierce had continued painting, but after the death of her husband, she ground to an artistic halt. "It was just like the end," recalls Pierce, "but nothing is ever really the end, is it?" Unable to find meaning in the contemporary art she saw around her, she sought other forms. Pierce sandblasted wooden doors and screens, then turned the sand blaster on rocks, creating objects that recall the idols and ritual vessels of ancient Mediterranean cultures. Realizing that she was coming up with archetypal ceremonial images, Pierce endeavored to get closer to the pre-Christian or non-Christian mind by studying traditional Native American religions. She took classes with noted ethnographer Florence Ellis, then befriended a Jemez Pueblo Indian who took her to ceremonials for years.

By the late 1960s, Pierce decided to create monumental wall sculptures related to her sandblasted wood and stone forms. She shaped foam, covered it with cement aggregate, then added latex. The pieces began to resemble the desert cliffs of the Southwest. Pierce stumbled onto resin while trying to find a way to incorporate translucent rods into the sculpture, and discovered that spilled resin took on a certain glossy, shimmering character. Pierce has been exploring that "certain character" ever since. In order to retain the luminous quality of the resin, she pours it over plexiglass mirrors. She uses minimal color, focusing on the white, the transparency, the translucency—the same qualities that vibrate through her memories of that first Taos winter. Pierce's abstract sculptures are human scale, often from five to seven feet tall. They confront the viewer like shimmering ghosts, benevolent psychic companions, or scintillating stalagmites floating in crystalline caves.

Explaining the genesis of her works, Pierce says, "What I'm after is power and presence. I realize I'm using the same old things—the circle, triangle, square—that I used in Emil Bisttram's classes. They sort of reincarnated themselves in my life all these years later. That winter alone was like my initiation into what I'm doing now." She emphasizes, "This is about as pure 'Florence' as I can get. I was so pure, so naive then. I try to approach art again from that same mysterious source."–B.A.B.

A performance artist with a powerful presence, Rachel Rosenthal is so compelling on stage that her audience often perceives this just-over-five-feet tall woman as immense. Her impact is enhanced by both her consummate acting skills and by her ability to graphically transform the personal to the universal, to transmute the details of autobiography and the specifics of her concerns to themes of profound global impact. "I look at performing as transcendental lovemaking," explains Rosenthal. "I put everything in it—I put who I am in it, all my passion, all my vulnerability, all my intelligence. When I come on stage and I feel the energy of the audience, all my fears disappear and the performance becomes a ritual of communion. In that way, it is extremely nourishing."

Rosenthal grew up in a wealthy environment that was also a somewhat unusual one. Both parents had great expectations for their child; they wanted her to be an artist, but with a certain ambivalence. "There was always this encouragement, always 'Yes, Rachel will be an artist when she grows up,' but never any understanding of what that means in terms of commitment and lifestyle," observes Rosenthal. "I was totally confused about my identity first of all as an artist, secondly as a woman, thirdly as a woman artist—which was a real problem. I had really and truly absorbed the notion that to be an artist meant to be a male artist. So being a woman either I had to deny my femininity or I had to deny being an artist. For years and years I had this continual angst—going back and forth like a pendulum about being a woman and being an artist and never quite knowing where I was or which one I was, having a hazy self-image."

Rosenthal's family was one of the last to leave Paris before the onslaught of the German army during World War II. The family traveled to New York via Brazil where, in high school and for years after, Rosenthal focused on painting. She studied with the prominent artist/teacher Hans Hoffman and with art historian/critic Meyer Schapiro, however, she feels she never developed a painting style that was authentically her own. She also continued her involvement with the theater and spent her 20s shuttling between Paris and New York. Although she had a tremendous nostalgia for her native France, she had become a naturalized U.S. citizen. Just as she would settle into an involvement with the absurdist theater in Paris, her visa would run out and, feeling uprooted, she would move again to New York, where she became involved with Merce Cunningham and his "entourage"—painters Jasper Johns and Robert Rauschenberg and composer John Cage.

Rosenthal's father died in Los Angeles in 1955. She attended the funeral in L.A. and decided to stay. "I felt so overwhelmed by the New York talents that I was running around with that I felt I just could not find who I was," recalls Rosenthal. "Within moments of arriving in Los Angeles, I founded the Instant Theatre company and began to blossom as an improvisational theater person." Rosenthal ran the Instant Theatre from 1956 through 1966. Among the members of her early workshop were actors Vic Morrow, Anthony Perkins, Tab Hunter and Dean Stockwell. But in 1966, she had to give up her improvisational work because of the arthritic deterioration of her knees.

In the early 1970s, Rosenthal got involved with the Woman's Art Movement, especially through Miriam Schapiro, whom she had known in New York. "I was exposed to feminism in both literature and action—talk about trauma! For one thing, I had never had women friends before," admits Rosenthal. "Then suddenly I was surrounded by women who were obviously wonderful artists so I had to change my whole world view. In addition to which I had for 10 years been the sole dictator of a theatrical company and suddenly I was thrown into feminist democracy. Again, I had to confront and reappraise everything I was and everything I believed in. I was completely turned around and thrown into a tailspin." Out of that tailspin emerged Rachel Rosenthal, the performance artist.

Rosenthal's work from 1975 through 1981 was primarily autobiographical, although she always used her life events as metaphors for larger issues. Her first performance, "Replays," was performed in 1975. Composed shortly after her mother's death, it dealt with how her knees had so flared up after her mother's passing that she couldn't walk, as if her mother hadn't left her with a leg to stand on. In 1981, she did a powerfully realistic piece entitled "Soldier of Fortune," which dealt with how all of her money had been embezzled. After that, she was no longer solely interested in reconstructing her life through art. Since 1982, she has explored issues such as nuclear power, toxic waste, feminism, animal rights, the collision of spirituality and technology, and the relationship between humans and the planet. Rosenthal has manifest social goals in her work, goals that have to do with what she terms 'deep ecology.' "I need to know that the earth is given a chance to survive and that she will continue long after we are gone."–B.A.B.

THE WRITERS

ARLENE RAVEN is an art historian writing criticism for the "Village Voice" and a variety of art magazines and scholarly journals. Her collected essays were published in book form, *Crossing Over: Feminism and Art of Social Concern* (1988). Raven was editor of *Feminist Art Criticism: An Anthology* (1988) and *Art in the Public Interest* (1989). She studied at Hood College, George Washington University and Johns Hopkins University, and holds an M.F.A. in painting and a Ph.D in art history.

Raven has received numerous grants and awards, including two National Endowment for the Arts art critic's fellowships. She has curated exhibitions for a number of institutions and was a founder of the Women's Caucus for Art, the Los Angeles Woman's Building and "Chrysalis" magazine.

BETTY ANN BROWN is an art historian, critic and curator. She received her Ph.D. in art history from the University of New Mexico in 1977 and holds the position of Associate Professor in the Department of Art at California State University, Northridge. Brown's academic training includes Latin American art and she has published extensively in that field. Her art criticism has appeared in "ARTS Magazine" and "Artscene," among others. She is currently a contributing editor of "Artweek" and was founding editor of "Visions Magazine."

Brown has curated exhibitions nationally and internationally. She is currently organizing an exhibition of Spanish women artists, scheduled to tour the U.S. in 1992, as well as co-editing a book on feminist criticism to be published by the L.A. Woman's Building in 1990. Brown lives in Pasadena, California with her young son Wiley.

ALESSANDRA COMINI, who wrote the Foreword for *Exposures, Women & Their Art*, is University Distinguished Professor of Art History at Southern Methodist University. She is the author of six books, ranging from *The Portraits of Egon Schiele*, nominated for the 1974 National Book Award, to *The Fantastic Art of Vienna to The Changing Image of Beethoven: A Study in Mythmaking*. Comini received her Ph.D. from Columbia University where she taught for 10 years. She has also taught at Yale and UC Berkeley and has been voted "outstanding professor" eight times by her students.

Long a promoter of women's art, Comini has published and lectured extensively in the United States and abroad on women's issues, concentrating on 19th- and 20th-century European and American sculptors and painters. In demand as an interdisciplinary musicologist, she has advanced the cause of women composers such as Clara Schumann and Alma Mahler. Comini's articles and essays on women artists can be found in the publications of The National Museum for Women in the Arts in Washington, D.C. as well as in other arts publications.

THE PHOTOGRAPHER

KENNA LOVE has been a commercial photographer for the past 15 years. Her work has been published in numerous publications, including "Visions Magazine," "Art Quarterly," and "Los Angeles Magazine." While on assignment for "Nissan Discovery" magazine, photographing Los Angeles artists, women shared with her their concern about the inequality of exposure between men and women artists. As Love began to understand the critical need for women artists in the United States to reach a wider audience, she felt that her photographs would help expose the power of these artists and their work. In collaboration with the writers, Love feels that the photographs and text for *Exposures, Women & Their Art* achieves this purpose.